The Essential Kabbalah

The
Essential
Kabbalah

The Heart
of Jewish
Mysticism

Daniel C. Matt

CASTLE BOOKS

Published by CASTLE BOOKS
A Division of Book Sales, Inc.
114 Northfield Avenue, Edison, New Jersey 08837

ISBN 0-7858-0870-1

MANUFACTURED IN THE UNITED STATES OF AMERICA.

For Ana

On her tongue, a Torah of love

Contents

Foreword

KABBALAH, the Jewish mystical tradition, is precious and well hidden. Its symbolism, allusions, and multiple layers of meaning have attracted and confounded readers for centuries. Having studied Kabbalah for some twenty-five years, my attraction has not abated; my confoundedness has not been eliminated, but seasoned by wonder.

In this book I offer a selection of what I consider to be essential teachings from the immense trove of Kabbalah. I have translated the passages from the original Hebrew and Aramaic texts, and supplied notes to guide you through the maze. The introduction traces the history of Kabbalah and explains its salient concepts and symbols. A brief bibliography suggests titles for further study. In rendering the passages from Kabbalah into English, I have at times omitted material. I have taken the liberty of not indicating these omissions with ellipses, so as not to interrupt the flow of the translation. Precise citations are provided in the notes, so that interested readers can refer back to the original.

A number of friends and colleagues have been kind enough to offer advice or read parts of the manuscript. I would like to thank Arnold Eisen, Moshe Idel, Yehuda Liebes, Ehud Luz, and Elliot Wolfson. I am grateful to John Loudon, executive editor at Harper San Francisco, for inviting me to compose this book and for encouraging me along the way.

The Ten Sefirot

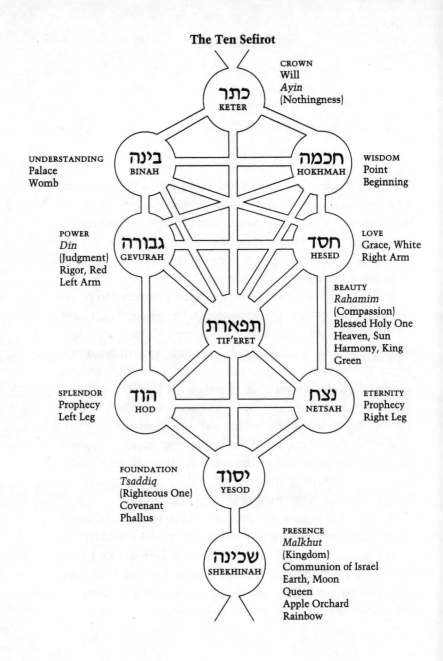

CROWN
Will
Ayin
(Nothingness)

UNDERSTANDING
Palace
Womb

WISDOM
Point
Beginning

POWER
Din
(Judgment)
Rigor, Red
Left Arm

LOVE
Grace, White
Right Arm

BEAUTY
Rahamim
(Compassion)
Blessed Holy One
Heaven, Sun
Harmony, King
Green

SPLENDOR
Prophecy
Left Leg

ETERNITY
Prophecy
Right Leg

FOUNDATION
Tsaddiq
(Righteous One)
Covenant
Phallus

PRESENCE
Malkhut
(Kingdom)
Communion of Israel
Earth, Moon
Queen
Apple Orchard
Rainbow

כתר
KETER

בינה
BINAH

חכמה
HOKHMAH

גבורה
GEVURAH

חסד
HESED

תפארת
TIF'ERET

הוד
HOD

נצח
NETSAH

יסוד
YESOD

שכינה
SHEKHINAH

Introduction:
A Glimpse of the Orchard

THE HEBREW word *kabbalah* means "receiving" or "that which has been received." On the one hand, Kabbalah refers to tradition, ancient wisdom received and treasured from the past. On the other hand, if one is truly receptive, wisdom appears spontaneously, unprecedented, taking you by surprise.

The Jewish mystical tradition combines both of these elements. Its vocabulary teems with what the *Zohar*—the canonical text of the Kabbalah—calls "new-ancient words." Many of its formulations derive from traditional sources—the Bible and rabbinic literature—but with a twist. For example, "the world that is coming," a traditional phrase often understood as referring to a far-off messianic era, turns into "the world that is constantly coming," constantly flowing, a timeless dimension of reality available right here and now, if one is receptive.

The rabbinic concept of *Shekhinah*, divine immanence, blossoms into the feminine half of God, balancing the patriarchal conception that dominates the Bible and the Talmud. Kabbalah retains the traditional discipline of Torah and *mitsvot* (commandments), but now the mitsvot have cosmic impact: "The secret of fulfilling the mitsvot is the mending of all the worlds and drawing forth the emanation from above."[1] According to Kabbalah, every human action here on earth affects the divine realm, either promoting or hindering the union of Shekhinah and her partner—the Holy One, blessed be he. God is not static being, but dynamic becoming. Without

human participation, God remains incomplete, unrealized. It is up to us to actualize the divine potential in the world. God needs us.

Kabbalah owes its success to this piquant blend of tradition and creativity, loyalty to the past and bold innovation. The kabbalists grew adept at walking the tightrope between blind fundamentalism and mystical anarchy, though a number of them lost their balance and fell into one extreme or the other. Remarkably, despite their startling ideas and sometimes shocking imagery, the kabbalists aroused relatively little opposition, compared to some of the famous Islamic Sufis and Catholic mystics such as Hallaj and Meister Eckhart. No doubt this was due in part to the esoteric method of transmitting Kabbalah. At first, the secret teachings were conveyed orally from master to disciple and restricted to small circles. Even when written down, the message was often cryptic, sometimes concluding: "This is sufficient for one who is enlightened," or "The enlightened one will understand," or "I cannot expand on this, for thus have I been commanded."

From the beginning of the movement in the twelfth and thirteenth centuries, the Kabbalah was promoted by renowned, learned rabbis such as Rabad of Posquières and Nahmanides. Strongly committed to traditional observance, the kabbalists could not easily be attacked as radicals. But they were profoundly radical, and they touched something deep in the human soul.

The kabbalists made the fantastic claim that their mystical teachings derived from the Garden of Eden. This suggests that Kabbalah conveys our original nature: the unbounded awareness of Adam and Eve. We have lost this nature, the most ancient tradition, as the inevitable consequence of tasting the fruit of knowledge, the price of maturity and culture. The kabbalist yearns to recover that primordial tradition, to regain cosmic consciousness, without renouncing the world.

Visions of God

Kabbalah emerges as a distinct movement within Judaism in medieval Europe, but the experience of direct contact with the divine is already evident in the earliest Jewish book—the Bible. When Moses encounters God at the burning bush, he is overwhelmed: "afraid to look at God," he hides his face. Soon God reveals the divine name, "I am that I am," intimating what eventually becomes a mystical refrain: God cannot be defined (Exodus 3:6, 14). Later, at Mt. Sinai, Moses asks to see the divine presence, but God tells him, "No human can see me and live." Yet the Torah concludes by saying that God knew Moses "face to face" (Exodus 33:20; Deuteronomy 34:10). The prophet Isaiah sees God enthroned in the Temple in Jerusalem, accompanied by fiery angels who call out to one another, "Holy, holy, holy is the Lord of hosts. The whole earth is filled with his presence" (Isaiah 6:3). The most graphic account of a vision of God is undoubtedly the opening chapter of the book of Ezekiel. Standing by a river in Babylon, the prophet sees a throne whirling through heaven, accompanied by four winged creatures darting to and fro. On the throne is "a figure with the appearance of a human being," surrounded by radiance like a rainbow.

Ezekiel experienced this vision near the beginning of the sixth century B.C.E. Even before his book was canonized as part of the Bible, his vision had become the archetype of Jewish mystical ascent. Until the emergence of Kabbalah, Jewish mystics used Ezekiel's account as their model. *Ma'aseh merkavah*, the account of the chariot—as it came to be called—was expounded in some circles, imitated in others. An entire literature developed recounting the visionary exploits of those who followed in Ezekiel's footsteps, among them some of the leading figures of rabbinic Judaism. The journey was arduous and dangerous, requiring intense, ascetic

preparation and precise knowledge of secret passwords in order to be admitted to the various heavenly palaces guarded by menacing angels. The final goal was to attain a vision of the divine figure on the throne.

The danger of the mystical search is conveyed by a famous report in the Talmud of four rabbis who ventured into *pardes*, the divine orchard, or paradise:

> Four entered pardes: Ben Azzai, Ben Zoma, Aher,
> and Rabbi Akiva. Ben Azzai glimpsed and died.
> Ben Zoma glimpsed and went mad. Aher cut
> the plants. Rabbi Akiva emerged in peace.[2]

Aher, "the other one," is the nickname of Elisha ben Avuyah, the most famous heretic in rabbinic literature. The exact nature of his heresy is unclear; the metaphor of "cutting the plants" may refer to his conversion to Gnostic dualism. In any case, only Rabbi Akiva, we are told, emerged unscathed.

Certain Jewish mystics went so far as to formulate detailed descriptions of the body of God. These texts became known as *Shi'ur Qomah*, "the measurement of the [divine] stature." Such extreme anthropomorphism generated criticism, such as that of Moses Maimonides, but it also influenced the bold mythical language of the Kabbalah.

Secrets of Creation

The account of Ezekiel's chariot formed one major branch of early Jewish mysticism. The other branch was *ma'aseh bereshit*, the account of creation, or cosmology. The most important text concerning these secrets was *Sefer Yetsirah, The Book of Creation*, composed apparently in Palestine sometime between the third and sixth centuries. Here we are told how God created the world by means of the twenty-two let-

ters of the Hebrew alphabet and the ten *sefirot*—a term that appears for the first time in Hebrew literature. Genesis and Psalms had already indicated that divine speech was the tool of creation. "God said, 'Let there be light, and there was light.'" "By the word of God the heavens were made; by the breath of his mouth, all their hosts" (Genesis 1:1; Psalms 33:6). What is new in *Sefer Yetsirah* is the detailed speculation on how God combined the individual letters, as well as the idea of the sefirot, which in this text are numerical entities, living beings embodying the numbers one through ten, ciphers, metaphysical potencies through which creation unfolds. The notion that numbers are essential to the structure of the cosmos derives from Pythagorean mysticism. Gradually, however, the sefirot evolved into something more, becoming the central symbol system of Kabbalah.

The Zohar

Based on these earlier traditions, Kabbalah emerged in its own right in the fertile region of Provence toward the end of the twelfth century. Here a variegated Jewish community flourished, a center of learning that encompassed rabbinic law, philosophy, and mysticism. *Sefer ha-Bahir*, usually considered the first kabbalistic text, was edited here. Ironically, although *bahir* means "bright" or "clear," this small book is unimaginably obscure: an often impenetrable collection of esoteric fragments. In it, the sefirot now appear as lights, powers, and attributes, similar to the divine potencies described in Gnostic literature. They represent stages of God's inner life, aspects of the divine personality. There is no unified scheme; the sefirot are described in various and conflicting ways. Over the next hundred years, as Kabbalah spread over the Pyrenees into Catalonia and then to Castile, the symbolic system crystallized. Elements of Neoplatonic mysticism were incorporated, as well as speculations on the origin of evil.

Around the year 1280, a Spanish Jewish mystic named Moses de León began circulating booklets to his fellow kabbalists. Written in lyrical Aramaic, they were replete with nonce words, arcane symbolism, and erotic imagery. The tales and teachings were esoteric, yet enchanting. Moses claimed that he was merely the scribe, copying from an ancient book of wisdom. The original had supposedly been composed in the circle of Rabbi Shim'on bar Yohai, a famous disciple of Rabbi Akiva who lived and taught in the second century in the land of Israel.

These booklets were the first installments of an immense work: *Sefer ha-Zohar, The Book of Radiance*. De León's claim was widely accepted, and the *Zohar*'s ostensible pedigree helped promote the young kabbalistic movement. Few dared to challenge the ancient teachings of Shim'on bar Yohai and the *havrayya*, his mystical companions. The *Zohar* gradually became *Ha-Zohar ha-Qadosh, The Holy Zohar*, the canonical text of Kabbalah, and most subsequent Kabbalah was based on its teachings. Only in relatively recent times has Moses de León's actual role in the *Zohar*'s generation become more clear.

More than a scribe, De León was the composer of the *Zohar*. He drew on earlier material; he may have collaborated with other kabbalists; and he may have genuinely believed that he was transmitting ancient teachings.[3] Indeed, parts of the *Zohar* may have been composed through automatic writing, a technique in which the mystic would meditate on a divine name, enter a trance, and begin to "write whatever came to his hand." Such a technique was reportedly used by other thirteenth-century kabbalists. But Moses de León wove his various sources into a masterpiece: a commentary on the Torah in the form of a mystical novel. Rabbi Shim'on and the havrayya wander through Galilee exchanging kabbalistic insights. On one level, biblical heroes such as Abraham and Moses are the protagonists, and the rabbis interpret their

words, actions, and personalities. The text of the Torah is simply the starting point, a springboard for the imagination. At times, the commentators become the main characters, and we read about dramatic mystical sessions with Rabbi Shim'on or about the companions' encounters with strange characters on the road, such as an old donkey driver who turns out to be a master of wisdom in disguise.

The Sefirot

The plot of the *Zohar* focuses ultimately on the sefirot. By penetrating the literal surface of the Torah, the mystical commentators transform the biblical narrative into a biography of God. The entire Torah is read as a divine name, expressing divine being.[4] Even a seemingly insignificant verse can reveal the inner dynamics of the sefirot—how God feels, responds, and acts, how She and He relate intimately with each other and with the world. The opening chapter of Genesis appears to describe the creation of the world, but it alludes to a more primal beginning—the emanation of the sefirot, their emergence from the Infinite, or *Ein Sof* (literally, "Endless").[5] In contrast to the personal God of the sefirot, Ein Sof represents the radical transcendence of God. Not much more than its name can be said. Here the Jewish mystics adopted the negative theology of Maimonides, who had taught:

> The description of God by means of negations is the correct description—a description that is not affected by an indulgence in facile language. . . . With every increase in the negations regarding God, you come nearer to the apprehension of God.[6]

The first sefirah shares in the negative nature of Ein Sof and is sometimes referred to as *Ayin*, Nothingness. As one kabbalist puts it, "Ayin is more existent than all the being of

the world. But since it is simple, and every simple thing is complex compared with its simplicity, it is called Ayin."[7] In this primal state, God is undifferentiated being, neither this nor that, no-thingness.

The first sefirah is more commonly called *Keter*, Crown. It is the crown on the head of *Adam Qadmon*, Primordial Adam. According to the opening chapter of Genesis, the human being is created in the image of God. The sefirot constitute the divine archetype of that image, the mythical paragon of the human being, our original nature. Another depiction of the sefirot is that of a cosmic tree growing downward from its roots above, from Keter, "the root of roots."

Out of the depths of Nothingness shines the primordial point of *Hokhmah*, Wisdom, the second sefirah. This point expands into a circle, the sefirah of *Binah*, Understanding. Binah is the womb, the Divine Mother. Receiving the seed, the point of Hokhmah, she conceives the seven lower sefirot. Created being, too, has its source in her; she is "the totality of all individuation."[8]

These three highest sefirot (Keter, Hokhmah, and Binah) represent the head of the divine body and are considered more hidden than the offspring of Binah. She gives birth first to *Hesed* (Love) and *Gevurah* (Power), also known as *Din* (Judgment). Hesed and Gevurah are the right and left arms of God, two poles of the divine personality: free-flowing love and strict judgment, grace and limitation. For the world to function properly, both are essential. Ideally a balance is achieved, symbolized by the central sefirah, *Tif'eret* (Beauty), also called *Rahamim* (Compassion). If judgment is not softened by love, it lashes out and threatens to destroy life. Here lies the origin of evil, called *Sitra Ahra*, the Other Side. From a more radical perspective, evil originates in divine thought, which eliminates waste before emanating goodness. The demonic is rooted in the divine.

Tif'eret is the trunk of the sefirotic body. He is called Heaven, Sun, King, and the Holy One, blessed be he, the standard rabbinic name for God. He is the son of Hokhmah and Binah. The next two sefirot are *Netsah* (Eternity) and *Hod* (Splendor). They form the right and left legs of the body and are the source of prophecy. *Yesod* (Foundation) is the ninth sefirah and represents the phallus, the procreative life force of the universe. He is also called *Tsaddiq* (Righteous One), and Proverbs 10:25 is interpreted as applying to him: "The righteous one is the foundation of the world." Yesod is the *axis mundi*, the cosmic pillar. The light and power of the preceding sefirot are channeled through him to the last sefirah, *Malkhut*.

Malkhut (Kingdom) is also known as Shekhinah (Presence). In earlier Jewish literature, Shekhinah appears frequently as the immanence of God but is not overtly feminine. In Kabbalah, Shekhinah becomes a full-fledged She: daughter of Binah, bride of Tif'eret, the feminine half of God. Shekhinah is "the secret of the possible," receiving the emanation from above and engendering the varieties of life below.[9] The union of Shekhinah and Tif'eret constitutes the focus of religious life. Human righteous action stimulates Yesod, the Righteous One, and brings about the union of the divine couple. Human marriage symbolizes and actualizes divine marriage. Sabbath eve is the weekly celebration of the cosmic wedding, and the ideal time for human lovers to unite.

The mythical imagery of the sefirot is stunning. The kabbalists continually insist that these figures of speech should not be taken literally; they are organic symbols of a spiritual reality beyond normal comprehension. At the start of one of his most anthropomorphic descriptions, Rabbi Shim'on cites a verse from Deuteronomy: "Cursed be the one who makes a carved or molten image, the work of the hands of an artisan, and sets it up in secret."[10] Sefirotic descriptions are intended

to convey something of the beyond; becoming fixated on the image itself prevents genuine communication.

Critics charge that the theory of Ein Sof and the sefirot is dualistic, that by positing and describing ten aspects of divinity, Kabbalah verges on polytheism. As one iconoclastic kabbalist, Abraham Abulafia, noted, some adherents of the sefirot have outdone Catholic adherents of the trinity, turning God into ten![11] The kabbalists maintain that the sefirot and Ein Sof form a unity, "like a flame joined to a burning coal." "It is they, and they are it." "They are its name, and it is they."[12] From the human perspective, the sefirot appear to possess a multiple and independent existence. Ultimately, however, all of them are one; the true reality is the Infinite.[13] Nevertheless, the prominent mythological character of the system cannot be denied. In a sense Kabbalah represents "the revenge of myth," its resurgence after being attacked for centuries, after being pronounced dead by rationalist philosophers.[14] The kabbalists appreciate the profundity of myth and its tenacious appeal.

From above to below, the sefirot depict the drama of emanation, the transition from Ein Sof to creation. In the words of Azriel of Gerona, "They constitute the process by which all things come into being and pass away."[15] From below to above, the sefirot constitute a ladder of ascent back to the One. The union of Tif'eret and Shekhinah gives birth to the human soul, and the mystical journey begins with the awareness of this spiritual fact of life. Shekhinah is the opening to the divine: "One who enters must enter through this gate."[16] Once inside, the sefirot are no longer an abstract theological system; they become a map of consciousness. The mystic climbs and probes, discovering dimensions of being. Spiritual and psychological wholeness is achieved by meditating on the qualities of each sefirah, by imitating and integrating the attributes of God. "When you cleave to the sefirot, the divine holy spirit enters into you, into every sensation and every

movement."[17] But the path is not easy. Divine will can be harsh: Abraham was commanded to sacrifice Isaac in order to balance love with rigor.[18] From the Other Side, demonic forces threaten and seduce. Contemplatively and psychologically, evil must be encountered, not evaded. By knowing and withstanding the dark underside of wisdom, the spiritual seeker is refined.

Near the top of the sefirotic ladder, meditation reaches Binah. She is called *Teshuvah*, Return. The ego returns to the womb of being. Binah cannot be held in thought. She is called Who, the meditative question, "Who am I?" The questioning yields nothing that can be grasped, but rather, an intuitive flash illuminating and disappearing, as sunbeams play on the surface of water.[19]

In the depths of Binah lies Hokhmah, Wisdom. The mystic is nourished from this sphere. Profound and primal, it cannot be known consciously, only absorbed. In the words of Isaac the Blind, one of the earliest kabbalists of Provence, "The inner, subtle essences can be contemplated only by sucking, not by knowing."[20] Beyond Hokhmah is the Nothingness of Keter, the annihilation of thought. In this ultimate sefirah human consciousness expands, dissolving into Infinity.

Only rarely does the *Zohar* explicitly discuss meditation or mystical experience. It focuses on theosophy—the interplay of the sefirot—and on human conduct. Ethical and spiritual behaviors unite the sefirot, ensuring a flow of blessing and emanation to the lower worlds; unethical or evil human activities disrupt the union above, empowering demonic forces.

The Ecstatic Kabbalah

Alongside this theosophical system, other kabbalists developed an ecstatic Kabbalah. The emphasis here is on meditative techniques, especially the recitation of divine names and combinations of the letters of the Hebrew alphabet based on

Sefer Yetsirah. The most prominent ecstatic kabbalist was Abraham Abulafia. Born in Spain in 1240, Abulafia traveled and lived in Italy, Sicily, Greece, and the land of Israel. In his travels he may have been influenced by Sufism and yoga. He combined the teachings of *Sefer Yetsirah* with Maimonides' theory of prophecy, expounding a technique for achieving a state of inspiration through the fusion of the human and divine intellects.

According to Abulafia, the soul is part of the stream of cosmic life. Our awareness, though, is limited by sensory perceptions, our minds cluttered with sensible forms. The goal is "to untie the knots" that bind the soul, to free the mind from definitions, to move from constriction to the boundless. But how? If one meditates on abstract truths, however sublime, there is still a specific object of meditation, a limited meaning. Abulafia instead recommends focusing on the pure forms of the letters of the alphabet, or on the name of God. Here there is no concrete, particular meaning, no distraction, just the music of pure thought. As the highest form of this meditation, Abulafia recommends "jumping" or "skipping," a type of free association between various combinations of letters, guided by fairly lax rules. Thereby, consciousness expands.[21]

Abulafia came to see himself as playing a messianic role, and he actually attempted to meet with Pope Nicholas III in the summer of 1280, apparently to discuss theological and political questions. The pope condemned him to death by burning, but before the sentence could be carried out, the pope himself died. After a month in prison, Abulafia was released. His prophetic and messianic pretensions aroused the opposition of a leading rabbinic authority, Solomon Adret of Barcelona, who condemned Abulafia as a charlatan. As a result, he was forced to flee to the desolate island of Comino, near Malta, and his influence on Spanish Kabbalah was minimized. In the Middle East, though, ecstatic Kabbalah was readily accepted, and kabbalists such as Isaac of Akko reveal

clear traces of Abulafia's teachings. In Palestine, Abulafia's ideas were combined with Sufi elements, and in this way Sufi views were introduced into Kabbalah.[22]

The Safed Mystics: Cordovero and Luria

In 1492, the Jews were expelled from Spain. Along with tens of thousands of other exiles, kabbalists made their way to North Africa, Italy, and the eastern Mediterranean, disseminating mystical ideas. By the middle of the sixteenth century, Kabbalah, with the *Zohar* as its nucleus, had become an important spiritual factor in Jewish life.

A growing stream of kabbalists began arriving in Palestine. Jerusalem served as their first center, but beginning in the 1540s, the village of Safed became dominant. Perched high above the Sea of Galilee, commanding immense vistas, Safed seems to verge on heaven. The mystics here believed, based on a passage in the *Zohar*, that if one community lived a life of holiness, the Messiah would soon arrive. They strove to be that ideal community, supporting and urging one another. One of their ritual innovations was welcoming the Sabbath on Friday evening. Walking out to the fields before sunset, they would sing greetings to the Sabbath bride and queen, who was none other than Shekhinah, the feminine presence of God. A poem written in Safed for this occasion, *"Lekhah Dodi,"* opens with the words: "Come, my beloved, to greet the bride! Let us welcome the presence of the Sabbath." Today this poem is sung weekly in synagogues and Jewish homes throughout the world.

A leading figure in the mystical community of Safed was Moses Cordovero (1522–1570), who blended the *Zohar* with ecstatic Kabbalah, already flourishing in Jerusalem. His magisterial *Pardes Rimmonim (The Pomegranate Orchard)*, completed by the time he was twenty-seven, synthesized the teachings of the previous three centuries. On a more popular

level, he wrote *Or Ne'erav* (*The Sweet Light*), an introduction to Kabbalah, and *Tomer Devorah* (*The Palm Tree of Deborah*), a book of mystical ethics, showing how one can imitate God by embodying the qualities of the various sefirot. Soon a whole genre of mystical ethical literature developed, spreading kabbalistic thought and practice widely.

After Cordovero's death in 1570, one of his students, Isaac Luria, was acknowledged as the mystical master. Born in Jerusalem, Luria lost his father at a young age, and his mother took him to Egypt, where he was brought up in the home of his wealthy uncle. He spent a considerable time in seclusion on an island in the Nile near Cairo, studying the *Zohar* and the works of Cordovero. Arriving in Safed in 1569 or 1570, he was able to study with Cordovero for only a short time before his teacher passed away.

Luria's profound influence was due to his saintly behavior, his occult powers, and his novel teachings. He would reveal to each of his disciples the root of his particular soul, its ancestry, and the transmigrations through which it had journeyed. Luria taught in Safed for only about two-and-a-half years before dying in an epidemic in the summer of 1572 at the age of thirty-eight. His fame spread quickly, and he became known as *Ha-Ari*, "the Lion," an acronym for "the divine Rabbi Isaac."

Unlike the prolific Cordovero, Luria wrote hardly anything. When asked by one of his disciples why he did not compose a book, Luria is reported to have said: "It is impossible, because all things are interrelated. I can hardly open my mouth to speak without feeling as though the sea burst its dams and overflowed. How then shall I express what my soul has received? How can I set it down in a book?"[23] We know of Luria's teachings from his disciples' writings, especially those of Hayyim Vital.

Luria pondered the question of beginnings. How did the process of emanation start? If Ein Sof pervaded all space, how

was there room for anything other than God to come into being? Elaborating on earlier formulations, Luria taught that the first divine act was not emanation, but withdrawal. Ein Sof withdrew its presence "from itself to itself," withdrawing in all directions away from one point at the center of its infinity, as it were, thereby creating a vacuum. This vacuum served as the site of creation. According to some versions of Luria's teaching, the purpose of the withdrawal was cathartic: to make room for the elimination of harsh judgment from Ein Sof.

Into the vacuum Ein Sof emanated a ray of light, channeled through vessels. At first, everything went smoothly; but as the emanation proceeded, some of the vessels could not withstand the power of the light, and they shattered. Most of the light returned to its infinite source, but the rest fell as sparks, along with the shards of the vessels. Eventually, these sparks became trapped in material existence. The human task is to liberate, or raise, these sparks, to restore them to divinity. This process of *tiqqun* (repair or mending) is accomplished through living a life of holiness. All human actions either promote or impede tiqqun, thus hastening or delaying the arrival of the Messiah. In a sense, the Messiah is fashioned by our ethical and spiritual activity. Luria's teaching resonates with one of Franz Kafka's paradoxical sayings: "The Messiah will come only when he is no longer necessary; he will come only on the day after his arrival."[24]

Kabbalah's Continuing Influence

The Lurianic myth of *tsimtsum* ("contraction" or withdrawal), *shevirah* (shattering), and tiqqun became central to Kabbalah. Whereas Spanish Kabbalah had been restricted to an aristocratic elite, by the middle of the seventeenth century elements of Luria's theology and a number of his ritual innovations had spread throughout much of the Jewish world. Later, Lurianic Kabbalah strongly influenced Hasidism, the

eighteenth-century revivalist movement in Eastern Europe. Hasidism popularized and psychologized various kabbalistic ideas. In the words of Dov Baer, the Maggid (Preacher) of Mezritch, "I teach everyone that all the things described in the book *Ets Hayyim* pertain also to this world and to the human being."[25]

"Raising the sparks" served as a frequent Hasidic motif. Since all material existence is animated by the divine, even the most mundane activity can serve as an opportunity to discover God. This attitude also characterized the life and thought of the most original kabbalist of the twentieth century, Abraham Isaac Kook (1865–1935), who taught that all existence is the body of God.[26] As chief rabbi of Palestine, he blended profound mystical speculation with social and political activism. For Kook, the secular and the holy are not fundamentally distinct; secularism participates in the larger scheme of religious evolution. Even heresy plays a spiritual role, challenging us to continually expand our concept of God.[27]

Although Kabbalah emerged within Judaism, and has deeply affected Jewish thought and religious observance, its influence extends far beyond. Italian Renaissance humanist Pico della Mirandola immersed himself in Latin translations of Kabbalah, believing it to be the original divine revelation. Long lost and now finally restored, Kabbalah would enable Europeans to comprehend Pythagoras, Plato, and the secrets of Catholic faith. Pico claimed that "no science can better convince us of the divinity of Jesus Christ than magic and the Kabbalah."[28] His controversial, syncretistic 900 *Theses* drew heavily on Kabbalah and laid the foundation for Christian kabbalistic literature.

Pico's follower, Johannes Reuchlin, produced the first systematic work of Christian Kabbalah, *De arte cabalistica*. In the seventeenth century, Knorr von Rosenroth assembled translations of many important texts in *Cabbala denudata*

(*The Kabbalah Unveiled*), an anthology widely read by European thinkers. Figures such as Gottfried Leibniz, Gotthold Lessing, Emanuel Swedenborg, and William Blake absorbed kabbalistic ideas. In the twentieth century, traces of Kabbalah can be found, for example, in the fiction and poetry of Franz Kafka and Jorge Luis Borges, in the thought of Walter Benjamin, and in Jacques Derrida's Deconstruction. For the contemporary spiritual seeker, Kabbalah has become a rich and vital resource.

TRADITIONALLY, RESTRICTIONS have been placed on the study of Kabbalah. Some kabbalists insisted that anyone seeking entrance to the orchard must be at least forty years old, though Moses Cordovero stipulated twenty years. Other requirements included high moral standards, prior rabbinic learning, being married, and mental and emotional stability. The point is not to keep people away from Kabbalah, but to protect them. Mystical teachings are enticing, powerful, and potentially dangerous. The spiritual seeker soon discovers that he or she is not exploring something "up there," but rather the beyond that lies within. Letting go of traditional notions of God and self can be both liberating and terrifying. In the words of Isaac of Akko, "Strive to see supernal light, for I have brought you into a vast ocean. Be careful! Strive to see, yet escape drowning."[29]

NOTES

1. Moses de León, *The Book of the Pomegranate: Sefer ha-Rimmon*, ed. Elliot R. Wolfson (Atlanta: Scholars Press, 1988), 388; see Daniel C. Matt, "The Mystic and the *Mitsvot*," in *Jewish Spirituality: From the Bible through the Middle Ages*, ed. Arthur Green (New York: Crossroad, 1986), 390.

2. Babylonian Talmud, *Hagigah* 14b.

3. On the complex question of the composition of the Zohar, see Gershom Scholem, *Major Trends in Jewish Mysticism*, 3d rev. ed. (New York: Schocken, 1961), 156–204; Daniel C. Matt, *Zohar: The Book of Enlightenment* (Mahwah, NJ: Paulist Press, 1983), 3–10; 25–32; Isaiah Tishby and Fischel Lachower, *The Wisdom of the Zohar* (New York: Oxford University Press, 1989), 1, introduction; Yehuda Liebes, "How the *Zohar* Was Written," in *Studies in the Zohar* (Albany: State University of New York Press, 1993), 85–138.

4. See Gershom Scholem, *On the Kabbalah and Its Symbolism* (New York: Schocken, 1965), 37–44.

5. See "The Creation of God," pp. 52–53.

6. Moses Maimonides, *Guide of the Perplexed*, tr. Shlomo Pines (Chicago: University of Chicago Press, 1963), 1:58–59.

7. David ben Abraham ha-Lavan, *Masoret ha-Berit*; see *"Ayin,"* p. 66.

8. *Zohar* 3:65b.

9. On Shekhinah as "the secret of the possible," see David ben Judah he-Hasid, *The Book of Mirrors: Sefer Mar'ot ha-Tsove'ot*, ed. Daniel C. Matt (Chico, CA: Scholars Press, 1982), introduction, 29.

10. *Zohar* 3:127b–128a (*Idra Rabba*), citing Deuteronomy 27:15.

11. See Matt, *Zohar*, 20.

12. *Zohar* 3:70a, 11b; *Sefer Yetsirah* 1:7 (see "The Ten *Sefirot*," p. 76).

13. See "The Wedding Celebration," p. 60.

14. On "the revenge of myth," see Scholem, *Major Trends in Jewish Mysticism*, 35.

15. See *"Ein Sof,"* p. 29.

16. *Zohar* 1:7b.

17. Joseph ben Hayyim; see Moshe Idel, *Kabbalah: New Perspectives* (New Haven: Yale University Press, 1988), 350, n. 333.

18. See *Zohar* 1:119b; Matt, *Zohar*, 72–74.

19. See "Ripples," p. 114.

20. See "Beyond Knowing," p. 113.

21. See Moshe Idel, *The Mystical Experience in Abraham Abulafia* (Albany: State University of New York Press, 1988), passim; Scholem, *Major Trends in Jewish Mysticism*, 119–55; "Letters of the Alphabet," pp. 101–108.

22. See Moshe Idel, "*Qabbalah*," in *The Encyclopedia of Religion*, ed. Mircea Eliade (New York: Macmillan, 1987), 11:121–22.

23. See Scholem, *Major Trends in Jewish Mysticism*, 254.

24. Franz Kafka, *Parables and Paradoxes*, ed. Nahum N. Glatzer (New York: Schocken, 1961), 81.

25. Dov Baer, *Or ha-Emet*, ed. Levi Yitshaq of Berditchev (Bnei Brak: Yahadut, 1967), 36c–d. *Ets Hayyim* (*The Tree of Life*), compiled by Hayyim Vital, is the most widely disseminated version of Lurianic Kabbalah.

26. Abraham Isaac Kook, *Orot ha-Qodesh* (Jerusalem: Mossad ha-Rav Kook, 1963–64), 2:356: "*Kol ha-yesh . . . shi'ur qomah rabbati.*"

27. See "Heretical Faith," pp. 32–35.

28. See Scholem, *Kabbalah* (Jerusalem: Keter, 1974), 197.

29. See "Drowning," p. 131.

THE PURPOSE OF the marriage of a woman and a man is
 union.
The purpose of union is fertilization.
The purpose of fertilization is giving birth.
The purpose of birth is learning.
The purpose of learning is to grasp the divine.
The purpose of apprehending the divine is to maintain the
 endurance of the one who apprehends with the joy of
 apprehension.

AN IMPOVERISHED person thinks that God is an old man with white hair, sitting on a wondrous throne of fire that glitters with countless sparks, as the Bible states: "The Ancient-of-Days sits, the hair on his head like clean fleece, his throne—flames of fire." Imagining this and similar fantasies, the fool corporealizes God. He falls into one of the traps that destroy faith. His awe of God is limited by his imagination.

But if you are enlightened, you know God's oneness; you know that the divine is devoid of bodily categories—these can never be applied to God. Then you wonder, astonished: Who am I? I am a mustard seed in the middle of the sphere of the moon, which itself is a mustard seed within the next sphere. So it is with that sphere and all it contains in relation to the next sphere. So it is with all the spheres—one inside the other—and all of them are a mustard seed within the further expanses. And all of these are a mustard seed within further expanses.

Your awe is invigorated, the love in your soul expands.

Ein Sof:
God as
Infinity

THE ESSENCE of divinity is found in every single thing—nothing but it exists. Since it causes every thing to be, no thing can live by anything else. It enlivens them; its existence exists in each existent.

Do not attribute duality to God. Let God be solely God. If you suppose that Ein Sof emanates until a certain point, and that from that point on is outside of it, you have dualized. God forbid! Realize, rather, that Ein Sof exists in each existent. Do not say, "This is a stone and not God." God forbid! Rather, all existence is God, and the stone is a thing pervaded by divinity.

•

BEFORE ANYTHING emanated, there was only Ein Sof. Ein Sof was all that existed. Similarly, after it brought into being that which exists, there is nothing but it. You cannot find anything that exists apart from it. There is nothing that is not pervaded by the power of divinity. If there were, Ein Sof would be limited, subject to duality, God forbid! Rather, God is everything that exists, though everything that exists is not God. It is present in everything, and everything comes into being from it. Nothing is devoid of its divinity. Everything is within it; it is within everything and outside of everything. There is nothing but it.

GOD'S ENCAMPMENT

WHEN YOU contemplate the Creator, realize that his encampment extends beyond, infinitely beyond, and so, too, in front of you and behind you, east and west, north and south, above and below, infinitely everywhere. Be aware that God fashioned everything and is within everything. There is nothing else.

GOD IS unified oneness—one without two, inestimable. Genuine divine existence engenders the existence of all of creation. The sublime, inner essences secretly constitute a chain linking everything from the highest to the lowest, extending from the upper pool to the edge of the universe.

There is nothing—not even the tiniest thing—that is not fastened to the links of this chain. Everything is catenated in its mystery, caught in its oneness. God is one, God's secret is one, all the worlds below and above are all mysteriously one. Divine existence is indivisible.

The entire chain is one. Down to the last link, everything is linked with everything else; so divine essence is below as well as above, in heaven and on earth. There is nothing else.

EACH OF us emerges from Ein Sof and is included in it. We live through its dissemination. It is the perpetuation of existence. The fact that we sustain ourselves on vegetation and animal life does not mean that we are nourished on something outside of it. This process is like a revolving wheel, first descending, then ascending. It is all one and the same, nothing is separate from it. Though life branches out further and further, everything is joined to Ein Sof, included and abiding in it.

Delve into this. Flashes of intuition will come and go, and you will discover a secret here. If you are deserving, you will understand the mystery of God on your own.

THERE MUST be a contraction of God's presence. For if we believe that Ein Sof emanated the emanation and does not clothe itself within, then everything that emanated is outside of it, and it is outside of everything. Then there are two, God forbid. So we must conclude that nothing is outside of God. This applies not only to the sefirot but to everything that exists, large and small—they exist solely through the divine energy that flows to them and clothes itself in them. If God's gaze were withdrawn for even a moment, all existence would be nullified. This is the secret meaning of the verse: "You enliven everything." So divinity flows and inheres in each thing that exists. This is the secret meaning of the verse: "God's presence fills the entire world." Contemplating this, you are humbled, your thoughts purified.

ANYTHING VISIBLE, and anything that can be grasped by thought, is bounded. Anything bounded is finite. Anything finite is not undifferentiated. Conversely, the boundless is called Ein Sof, Infinite. It is absolute undifferentiation in perfect, changeless oneness. Since it is boundless, there is nothing outside of it. Since it transcends and conceals itself, it is the essence of everything hidden and revealed. Since it is concealed, it is the root of faith and the root of rebellion. As it is written, "One who is righteous lives by his faith." The philosophers acknowledge that we comprehend it only by way of no.

Emanating from Ein Sof are the ten sefirot. They constitute the process by which all things come into being and pass away. They energize every existent thing that can be quantified. Since all things come into being by means of the sefirot, they differ from one another; yet they all derive from one root. Everything is from Ein Sof; there is nothing outside of it.

One should avoid fashioning metaphors regarding Ein Sof, but in order to help you understand, you can compare Ein Sof to a candle from which hundreds of millions of other candles are kindled. Though some shine brighter than others, compared to the first light they are all the same, all deriving from that one source. The first light and all the others are, in effect, incomparable. Nor can their priority compare with its, for it surpasses them; their energy emanates from it. No change takes place in it—the energy of emanation simply manifests through differentiation.

Ein Sof cannot be conceived, certainly not expressed, though it is intimated in every thing, for there is nothing outside of it. No letter, no name, no writing, no thing can

confine it. The witness testifying in writing that there is nothing outside of it is: "I am that I am." Ein Sof has no will, no intention, no desire, no thought, no speech, no action— yet there is nothing outside of it.

IN THE FLOW of the holy spirit, one feels the divine life force coursing the pathways of existence, through all desires, all worlds, all thoughts, all nations, all creatures.

•

EVOLUTION AND KABBALAH

THE THEORY of evolution accords with the secrets of Kabbalah better than any other theory. Evolution follows a path of ascent and thus provides the world with a basis for optimism. How can one despair, seeing that everything evolves and ascends? When we penetrate the inner nature of evolution, we find divinity illuminated in perfect clarity. Ein Sof generates, actualizes potential infinity.

ALL CONCEPTUAL entanglements among human beings and all the inner, mental conflicts suffered by each individual result solely from our cloudy concept of the divine. All thoughts, whether practical or theoretical, flow out of the endless divine ocean and return there.

Constantly clarify the mind, so that it be free of the dross of deceptive fantasies, groundless fears, bad habits, and deficiencies. By cleaving in love and full awareness to the source of life, the soul shines from the supernal light, and all feelings, thoughts, and actions are refined. As this fundamental awareness becomes clearer in the recesses of the soul, the sensation and excitement of cleaving to the divine is activated, conducting the entire course of your life.

The essence of faith is an awareness of the vastness of Infinity. Whatever conception of it enters the mind is an absolutely negligible speck in comparison to what should be conceived, and what should be conceived is no less negligible compared to what it really is. One may speak of goodness, of love, of justice, of power, of beauty, of life in all its glory, of faith, of the divine—all of these convey the yearning of the soul's original nature for what lies beyond everything. All the divine names, whether in Hebrew or any other language, provide merely a tiny, dim spark of the hidden light for which the soul yearns when it says "God." Every definition of God leads to heresy; definition is spiritual idolatry. Even attributing mind and will to God, even attributing divinity itself, and the name "God"—these, too, are definitions. Were it not for the subtle awareness that all these are just sparkling flashes of that which transcends definition—these, too, would engender heresy.

If consciousness is torn from its source it becomes impoverished, without value. The only remedy for it to shine vibrantly is to be joined to the illumination of faith, which transcends all specific values, thereby establishing all values. Everything attributed to God other than the vastness of Infinity is simply an explanation by which to attain the source of faith. One must draw a distinction between the essence of faith and its explanatory aids, as well as between the various levels of explanation.

From learning and knowing too little, the mind becomes desolate, which leads to much thinking about the essence of God. The deeper one sinks into the stupidity of this mental insolence, the more one imagines that one is approaching the sublime knowledge of God, for which all the world's great spirits yearn. When this habit persists over many generations, numerous false notions are woven, leading to tragic consequences, until eventually the individual, stumbling in darkness, loses material and spiritual vitality. The greatest impediment to the human spirit results from the fact that the conception of God is fixed in a particular form, due to childish habit and imagination. This is a spark of the defect of idolatry, of which we must always beware.

All the troubles of the world, especially spiritual troubles such as impatience, hopelessness, and despair, derive from the failure to see the grandeur of God clearly. It is natural for each individual creature to be humble in the presence of God, to nullify itself in the presence of the whole—all the more so in the presence of the source of all being, which one senses as infinitely beyond the whole. There is no sadness or depression in this act, but rather delight and a feeling of being uplifted, a sense of inner power. But when is it natural? When the grandeur of God is well portrayed in the soul, with clear awareness, beyond any notion of divine essence.

We avoid studying the true nature of the divine, and as a result, the concept of God has dimmed. The innermost point of the awareness of God has become so faint that the essence of God is conceived only as a stern power from whom you cannot escape, to whom you must subjugate yourself. If you submit to the service of God on this empty basis, you gradually lose your radiance by constricting your consciousness. The divine splendor is plucked from your soul.

Every sensitive spirit feels compelled to discard such a conception of God. This denial is the heresy that paves the way for the Messiah, when the knowledge of God runs dry throughout the world. The crude complacency of imagining divinity as embodied in words and letters alone puts humanity to shame. Heresy arises as a pained outcry to liberate us from this strange, narrow pit, to raise us from the darkness of letters and platitudes to the light of thought and feeling. Such heresy eventually takes its stand in the center of morality. It has a temporary legitimacy, for it must consume the filthy froth clinging to mindless faith. The real purpose of heresy is to remove the particular forms from the thought of the essence of all life, the root of every single thought. When this condition persists over several generations, heresy inevitably emerges as cultural expression, uprooting the memory of God and all religious institutions. But what type of uprooting is intended by divine providence? Removing the dross that separates us from genuine divine light. On the desolate ruins wrought by heresy, the sublime knowledge of God will build her temple. Utter heresy arises to purify the air of the wicked, insolent filth of thinking about the essence of divinity—an act of peeping that leads to idolatry. In itself this heresy is no better than what it attacks, but it is absolutely opposed to it, and out of the clash of these two opposites, humanity is aided immensely in approaching an enlightened awareness of God, which draws it

toward temporal and eternal bliss. Instead of wasting one's thought trying to break through to the essence of divinity, the mind will be illumined by pure morality and sublime power, which sparkle from the divine light and chart the paths of life.

Pure belief in the oneness of God has been blurred by corporeality. From time to time, this confusion is exposed. Whenever a corporeal aspect falls away, it seems as if faith itself has fallen, but afterward it turns out that, in fact, faith has been clarified. As the human spirit verges on complete clarity of faith, the final subtle shell of corporeality falls away—attributing existence to God. For truly, existence, however we define it, is immeasurably remote from God. The silhouette of this denial resembles heresy but when clarified is actually the highest level of faith. Then the human spirit becomes aware that the divine emanates existence and is itself beyond existence. What appeared to be heresy, now purified, is restored to purest faith. But this denial of existence in God—this return to the source of all being, to the essential vibrancy of all existence—requires exquisite insight. Each day one must trace it back to its authentic purity.

The infinite transcends every particular content of faith.

Ein Sof
and
the Sefirot

IN THE BEGINNING Ein Sof emanated ten sefirot, which are of its essence, united with it. It and they are entirely one. There is no change or division in the emanator that would justify saying it is divided into parts in these various sefirot. Division and change do not apply to it, only to the external sefirot.

To help you conceive this, imagine water flowing through vessels of different colors: white, red, green, and so forth. As the water spreads through those vessels, it appears to change into the colors of the vessels, although the water is devoid of all color. The change in color does not affect the water itself, just our perception of the water. So it is with the sefirot. They are vessels, known, for example, as *Hesed, Gevurah,* and *Tif'eret,* each colored according to its function, white, red, and green, respectively, while the light of the emanator—their essence—is the water, having no color at all. This essence does not change; it only appears to change as it flows through the vessels.

Better yet, imagine a ray of sunlight shining through a stained-glass window of ten different colors. The sunlight possesses no color at all but appears to change hue as it passes through the different colors of glass. Colored light radiates through the window. The light has not essentially changed, though so it seems to the viewer. Just so with the sefirot. The light that clothes itself in the vessels of the sefirot is the essence, like the ray of sunlight. That essence does not change color at all, neither judgment nor compassion, neither right nor left. Yet by emanating through the sefirot—the variegated stained glass—judgment or compassion prevails.

FIRST, YOU should know that the Creator, Ein Sof, is the cause of causes, one without a second, one that cannot be counted. Change and mutability, form and multiplicity, do not apply to it. The word "one" is used metaphorically, since the number one stands on its own and is the beginning of all numbers. Every number is contained within it potentially, while it inheres in every number in actuality.

The Creator is called one from this aspect: Ein Sof is present in all things in actuality, while all things are present in it potentially. It is the beginning and cause of everything. In this way oneness has been ascribed to the Creator; nothing can be added to this oneness or subtracted from it. Ein Sof is necessary being, just as the number one is necessary for all numbers, since without it no number can exist. If the number one were nullified, all numbers would be nullified, whereas if the numbers were nullified, the number one would not. Such is the power of one.

So it is with the Creator of all, the one who acts and sustains existence. If an action were nullified, the actor would not be nullified, since Ein Sof does not need anything. If existence were nullified, Ein Sof would not be nullified, since it does not need space and exists on its own.

Furthermore, you should know that Ein Sof emanated its sefirot, through which its actions are performed. They serve as vessels for the actions deriving from Ein Sof in the world of separation and below. In fact, its existence and essence spread through them.

These qualities possess unerasable names. *Keter* (Crown) is named Eheyeh; *Hokhmah* (Wisdom) is named Yah; *Binah* (Understanding) is named YHVH with the vowels of Elohim; Hesed (Love) is named El; Gevurah (Power) is named Elohim; Tif'eret (Beauty) is named YHVH; *Netsah* (Eternity) is named

Tseva'ot; *Yesod* (Foundation) is named Shaddai or El Hai; *Malkhut* (Kingdom) is named Adonai.

These names are the sefirot. It is not that the names are merely ascribed to the sefirot, God forbid; rather, the names *are* the sefirot. These sefirotic names are names of Ein Sof, according to its actions.

Ein Sof is not identical with Keter, as many have thought. Rather, Ein Sof is the cause of Keter; Keter is caused by Ein Sof, cause of causes. Ein Sof is the primal cause of all that exists; there is no cause higher than it. Keter is the first to derive from it. From Keter the rest of emanation is drawn forth. This does not contradict the fact that Keter is counted as one of the sefirot. It is reckoned as one of the ten, considered similar to the emanated ones. On account of its loftiness, however, Keter does not reveal itself in the emanated totality of ten. The decade is kept complete by including *Da'at* (Knowledge) in place of Keter.

It is inappropriate to say of Ein Sof "blessed be he," "glorified be he," "praised be he," or similar expressions, since it cannot be blessed, praised, or glorified by another. Rather, it is the one who blesses, praises, glorifies, and animates from the first point of its emanation to the farthest. Before the formation of the universe, it had no need of emanation. It was concealed in its holy, pure simplicity. No letter, vowel, or image can be applied to it, for even Keter, the beginning of emanation, is devoid of name and image in letter or vowel. How much more so with Ein Sof, whom we cannot depict, of whom we cannot speak, of whom we cannot posit either judgment or compassion, excitement or anger, change or limit, sleep or motion, or any quality whatsoever, either prior to the emanation or now.

At the very beginning, Ein Sof emanated the subtle emanation, namely, ten sefirot—noetic forms—from its essence, uniting with it. It and they together constitute a complete union. These sefirot are souls, which clothe themselves in

the ten sefirot called by name, which serve as vessels for the ten essences. Within these ten named sefirot are found judgment and compassion and the aforementioned actions, which we would not ascribe to Ein Sof.

Before these qualities emanated, they were utterly concealed within Ein Sof, utterly united with it. No image can be applied to them—not even a point; rather, they were united with it. Afterward, Ein Sof emanated one point from itself, one emanation. This is Keter, called *Ayin*, Nothingness, on account of its extreme subtlety, its cleaving to its source, such that being cannot be posited of it. From Keter a second point emanated in a second revelation. This is Hokhmah (Wisdom), called *Yesh*, Being, for it is the beginning of revelation and existence. It is called *yesh me-ayin*, "being from nothingness." Because it is the beginning of being and not being itself, it required a third point to reveal what exists. This is Binah (Understanding).

From these three sefirot emerged the six dimensions of providence, the sefirot from Hesed (Love) and below. First, Hesed from Hokhmah; then Gevurah (Power) emanated from Binah; then Tif'eret (Beauty) emanated from Keter. The revelation of all three of these came about through Binah, but the essential roots of Hesed and Tif'eret derived from Hokhmah and Keter respectively. Hidden within these three were Netsah (Eternity), *Hod* (Splendor), and Yesod (Foundation). Netsah was revealed from Hesed, Hod from Gevurah, and Yesod from Tif'eret. Malkhut (Kingdom) emanated along with the six dimensions.

The process of emanation can be pictured in three different ways, each of which is true. Either one after the other: Keter, Hokhmah, Binah, Hesed ... to Malkhut. Or else Keter, Tif'eret, Yesod, and Malkhut constitute one point, emanating to the end of Malkhut, while Hokhmah, Hesed, and Netsah constitute a second point, emanating until Netsah; and Binah, Gevurah, and Hod constitute a third point, emanating until

Hod. Alternatively, Keter, Hokhmah, and Binah, followed by Hesed, Gevurah, and Tif'eret, followed by Netsah, Hod, and Yesod. Malkhut is the entirety.

Among the kabbalists, the most widely accepted depiction of the sefirot is as follows: Keter, Hokhmah, and Binah in the form of a triangle. Beneath them, also in the form of a triangle, Hesed, Gevurah, and Tif'eret, followed by another triangle of Netsah, Hod, and Yesod. Centered beneath them is Malkhut. The upper sefirot need the lower ones, and the lower sefirot need the upper ones. So the power of the lower sefirot is in the upper ones, and the power of the upper sefirot is in the lower ones. All of them need Ein Sof, while it needs none of them.

These sefirot have no specific location, God forbid, though we depict them in such a way as to make them fathomable. In truth, though, Ein Sof is the location of its sefirot, and Keter is the location of nine sefirot, and Hokhmah is the location of eight, and Binah is the location of seven, and so on. Malkhut is the location of the world of creation, which is the location of the world of formation, which is the location of the world of actualization, until the emanation reaches the earth.

Various channels have been ascribed to these sefirot, signifying the path of the ray of illumination from the first sefirah to its recipient, and the pathway from the recipient back to the emanating sefirah, so that it can receive. The joining of these two aspects of light constitutes a channel. The various types of channels are actually innumerable. Among them are the following:

One from Keter to Hokhmah, one from Keter to Binah, and one from Keter to Tif'eret, totaling three.

One from Hokhmah to Binah, one from Hokhmah to Hesed, one from Hokhmah to Gevurah, and one from Hokhmah to Tif'eret, totaling four.

One from Binah to Hesed, one from Binah to Gevurah, and one from Binah to Tif'eret, totaling three.

One from Hesed to Netsah, one from Hesed to Gevurah, and one from Hesed to Tif'eret, totaling three.

One from Gevurah to Hod, and one from Gevurah to Tif'eret, totaling two.

One from Tif'eret to Netsah, one from Tif'eret to Hod, and one from Tif'eret to Yesod, totaling three.

One from Netsah to Hod, and one from Netsah to Yesod, totaling two.

One from Hod to Yesod, and one from Yesod to Malkhut.

Malkhut receives solely from Yesod, through whom she receives from them all. Without him, she cannot receive from any of them; without her, none of the sefirot can emanate to the lower worlds, for she is the essence of those worlds, conducting them. These are the major channels; their facets are infinite.

The sefirot have the power to perform opposite actions, at times manifesting judgment, at times compassion. They always agree on each action, for each sefirah acts only along with all the others, with their consent, through Malkhut.

Each sefirah is composed of all ten, yet they manifest particular combinations:

Sometimes a combination of three: Hesed, Din, and *Rahamim* (Love, Judgment, and Compassion).

Sometimes a combination of four: the three already mentioned and one composed of them all.

Sometimes five: Hesed, Gevurah, Tif'eret, Netsah, and Hod.

Sometimes six: the six dimensions.

Sometimes seven: the sefirot from Hesed to Malkhut.

Sometimes eight, including Binah.

Sometimes ten, from Keter on down, or from Hokhmah on down, with Da'at (Knowledge) completing the decade.

These various combinations are not what they seem to be, for the sefirot are never less than ten. Rather, all ten combine in these various modes, revealing themselves in illumination.

The origin of Judgment is on high, in the will of the emanator. However, it is concealed, as all of the qualities are concealed and unified within Keter and Ein Sof, to such an extent that they cannot be considered individual qualities. Similarly, the activity of Judgment is concealed in the first three sefirot, and it is not considered Judgment until its manifestation in Gevurah.

It is improper for the seeker to probe the essence of the first three sefirot, since they constitute the Divine Mind, Wisdom, and Understanding. It is also improper to probe the essence of the hidden substance that creates all that exists. Since it is one with its Will, Wisdom, and Understanding—its essential qualities—it is not proper to probe. However, it is not wrong for us to explore from Hesed and Gevurah on down, for these qualities have been emanated to conduct the beings below. Whoever explores them thoroughly is rewarded for his zeal. Concerning this it is written: "Let the mother go," referring to Binah (Understanding); "the children you may take," to search and explore.

The activities of Hesed abound; we will mention here what is apt for the seeker. First, grace—as indicated by its name—benefiting us, being good to us. Also, nullifying the power of the aliens, who accuse and vex us. The effects of this quality are found in all things that partake of whiteness, such as gems whose color is white, whose virtue derives from Hesed. Among its actions is love. Although love is aroused by the left, its essential purpose is on the right. Another of its actions is drawing a person toward wisdom through the power of Hokhmah, above on the right. Another is including Gevurah within itself in order to execute judgment tinged with love.

Among the actions of Gevurah are harsh judgment, as indicated by its name. It is a lash to discipline humanity. From here stem all the aliens that seduce and denounce. Its effects are found in all things that partake of the mystery of redness and heat, such as fire and the power of gems whose color is red, whose virtue is striking terror. Yet, as we have noted, love is also aroused by this quality. Wealth and sustenance, too, emanate from here, with the help of Binah, above. Every time that God listens to a prayer or a cry of distress, it is through this quality, with the help of Binah.

Among the actions of Tif'eret are beauty and splendor, as attested by its name. The reason is that splendor and beauty are composed of white and red, as it is written, "My beloved is white and ruddy." Within the mystery of this quality are all things compounded of red and white, fire and water, warmth and wetness, judgment and grace. Also derived from here is the color yellow in gems—like the yellow of the yolk of an egg. All of these emanate from this quality, and their virtues derive from its power. The Torah and the study of Torah both depend on Tif'eret. The birth of children depends on the upper sefirot, while its locus is here. The manna descended to Israel from this quality. Souls emanate from here as well, through the mysterious union of this quality with Malkhut. Such union takes place between these two sefirot, as well as between Hokhmah and Binah, but between none of the others.

Hokhmah and Binah are called man and woman, father and mother. Just as human sexual union requires the medium of genitalia, so above, these two qualities unite by means of the mystery of primordial Da'at, which mediates between father and mother. This union maintains and renews the sefirot, which are continually revitalized through their root, sunk deep within Binah and Hokhmah. The soul, which derives from Binah, shares in this renewal. However, every

union requires an arousal below, and the arousal of Binah stems from Malkhut.

This manner of union may be found in Tif'eret and Malkhut, who are male and female, groom and bride, lower father and mother, son and daughter of the upper couple, king and queen, the Holy One, blessed be he, and *Shekhinah*. All these are metaphors. Their union, however, requires an arousal from the lower world, from the souls of the righteous.

Foreplay ushers in the union. There is embrace at the hands of Hesed and Gevurah, as intimated in the Song of Songs: "His left hand beneath my head, his right arm embracing me." This implies that the emanation of Hesed flows into Tif'eret, uniting with it. Then Tif'eret flows into Gevurah, uniting with it. Now the groom is joined with both his arms. Then he receives the bride with his left arm, and Gevurah extends to Malkhut, emanating to her. Then the abundance of Hesed, the right arm, flows to her. Thus the left is below, and the right embraces above.

Accompanying the union is the aspect of the kiss. Undoubtedly, this kiss is the cleaving of spirit to spirit, the mystery of the union of the inner essence of the sefirot, illuminating one another through the mystery of the mouth, Malkhut being in Tif'eret, Tif'eret in Malkhut.

The benefits of this union are immense. From it derive male souls from the male side and female souls from the female side. Accompanying this union are Netsah and Hod, the two testicles of the male, along with Yesod, the mystery of the covenant. Thus the union is enacted.

THERE IS A balance between the two extremes, that is, between Hesed and Din, Love and Judgment. This balance is Rahamim, Compassion. Such extremes appear in three places, each of which includes a balance. The first polarity is between Netsah and Hod, and the harmonizer is Yesod. The

second polarity is Hesed and Gevurah, and the harmonizer is Tif'eret. The third polarity is Hokhmah and Binah, and the harmonizer is Tif'eret in the mystery of Da'at. Such harmonization entails mediating between the two extremes.

Colors are ascribed to the various sefirot, according to their actions. Thus white indicates compassion, red indicates judgment, and so on, as is well known. Regarding Keter, some say that it has no color, while others say that the whitest of whites is appropriate for it. Still others construe its color as black. These three colors correspond to its three aspects. First, by virtue of being with the emanator, it is black. Second, in and of itself, since it is not revealed to what is emanated, no color pertains to it. Third, in its aspect of emanating compassion through the other sefirot, it partakes of the mystery of whiteness.

The color of Hokhmah is the first of all the colors, just as this sefirah is the beginning of all activity. The colors commence with Hokhmah, and thus its color is blue, the first color to emerge out of black. Black is opened by blue. Some construe its color as sapphire, which is close to blue.

The color of Binah is green like grass, the reason being that this color includes red and white and their blend, namely, Hesed, Gevurah, and Tif'eret. It also includes the color blue, from Hokhmah. Thus all these qualities blend together in Binah.

You should realize that holy, spiritual entities are unlike lowly, human actions. For when a human being performs an action, the object acted upon acquires the desired form and by necessity loses its previous form and nature. Having been transformed, its previous state of existence is no longer recalled. This is not the case with the sefirot and with everything that develops from them, for their previous mode of

existence is not absent. Rather they evolve from one mode of existence to another. For example, when the sefirot were concealed within Keter, all of them were present there, and even after their emanation, they remain existent there. Keter does not lack and does not change. So it is with the emanation of the sefirot from Hokhmah, and on and on. They transform themselves and multiply without end.

THE LIGHT of the sefirot emanates and radiates from above to below in a direct path: Keter, Hokhmah, Binah, Hesed, Gevurah, Tif'eret, Netsah, Hod, Yesod, Malkhut. Having descended to the site of its status, the light is reflected back, from below to above: Keter in Malkhut, Hokhmah in Yesod, Binah in Hod, Hesed in Netsah, Gevurah in Tif'eret, Tif'eret in Gevurah, Netsah in Hesed, Hod in Binah, Yesod in Hokhmah, Malkhut in Keter. Here lies the mystery of the reflection of light from below to above, the mystery of the reversal of light, striking a mirror and returning to its source. Between each two qualities a conduit runs up and down. Within the quality itself, some flows from below to above, some from above to below.

THE EXISTENCE stemming from God, extending to the lowest point, is divided into four divisions. The first is *Atsilut*, Emanation, namely, the ten emanated sefirot, through which spreads the light of Ein Sof. The second is the realm of the Throne of Glory, called *Beri'ah*, Creation. The light of the ten sefirot spreads through it—called here the sefirot of Creation. Thus the light of Ein Sof clothes itself in them through the medium of emanated light.

The third realm comprises ten bands of angels and the celestial palaces. The light of the ten sefirot spreads also through them, through the light of the ten sefirot of Creation. This realm is called *Yetsirah*, Formation, and as the sefirot

spread through them, they are called the ten sefirot of Formation. Thus the light of Ein Sof clothes itself through emanated light.

The fourth realm is the heavens and the entire material world. This is called *Asiyyah*, Actualization, and it includes ten heavens. The light of the sefirot spreads through them, and they are called the ten sefirot of Actualization. Here holiness pervades physical matter.

So these four are called Atsilut, Beri'ah, Yetsirah, Asiyyah; Emanation, Creation, Formation, Actualization. Their acronym is *ABiYA*. Emanation transcends Creation, Creation transcends Formation, Formation transcends Actualization. All four divisions are found in each one, since the degrees descend from cause to caused.

WHILE THERE are many unerasable names—the ten divine names of the ten sefirot—there exists one name that comprises all ten sefirot. This is the four-letter name: YHVH. Y symbolizes Hokhmah; H, Binah; V includes six sefirot; the final H, Malkhut. Ein Sof is concealed within Keter, while its light spreads through these four letters, from *yod* to *he*, from *he* to *vav*, from *vav* to final *he*.

THE RIGHTEOUS are capable of becoming a vehicle for the sefirot, through the mystery of the emanation of their souls, their actions in this world, and their inclination toward one side and toward one of the sefirot. Thus Abraham was a man of Hesed, Isaac a man of Gevurah, Jacob master of Tif'eret, Moses master of Netsah, Aaron master of Hod, Joseph master of Yesod, and David master of Malkhut.

ELIJAH OPENED and said, "Master of the worlds! You are one—but not in counting. You are higher than the high, concealed from the concealed. No thought grasps you at all. It is you who generated ten adornments—called by us the ten sefirot—by which concealed, unrevealed worlds are conducted, and revealed worlds. In them you conceal yourself from human beings, while you are the one who binds and unites them. Since you are within, whoever separates one of these ten from another—it is as if he divided you.

"These ten sefirot proceed in order: one long, one short, one between. It is you who conducts them, and no one conducts you—neither above nor below nor in any direction. You have prepared garments for them, from which souls fly to human beings. You have prepared various bodies for them—called bodies in contrast to the garments covering them. These bodies are named according to this arrangement: Hesed, the right arm; Gevurah, the left arm; Tif'eret, the trunk of the body; Netsah and Hod, the two legs; Yesod, completion of the body, sign of the holy covenant; Malkhut, the mouth—we call her oral Torah. Hokhmah is the brain, inner thought. Binah is the heartmind, through which the [human] heartmind understands. The highest crown, *Keter Elyon*, is the royal crown, the skull, inside of which is: yod he vav he, path of emanation, sap of the tree, spreading through its arms and branches—like water drenching a tree, which then flourishes.

"Master of the worlds! You are the cause of causes, who drenches the tree with that flow—a flow that is like a soul for the body, life for the body. In you there is neither likeness nor image of anything within or without. You created heaven and earth, bringing forth sun, moon, stars, and constellations. And on earth: trees, grass, the Garden of Eden, animals, birds,

fish, and human beings. So that the beyond might be known—how above and below conduct themselves and how they become known.

"About you, no one knows anything. Apart from you, there is no union above and below. You are known as Lord of all. Every one of the sefirot has a name that is known, by which the angels are called, but you have no known name, for you pervade all names; you are the fullness of them all. When you disappear from them, all those names are left like a body without a soul.

"You are wise—not with a known wisdom. You understand—not with known understanding. You have no known place—just making known your power and strength to human beings, showing them how the world is conducted by justice and compassion, according to human action. But actually you have no known justice or compassion, nor any quality at all."

In the beginning

WHEN THE KING conceived ordaining
he engraved engravings in the luster on high.
A blinding spark flashed within the concealed of the
 concealed
from the mystery of the Infinite,
a cluster of vapor in formlessness, set in a ring,
not white, not black, not red, not green, no color at all.
When a band spanned, it yielded radiant colors.
Deep within the spark gushed a flow, imbuing colors below,
concealed within the concealed of the mystery of the
 Infinite.
The flow broke through and did not break through its aura.
It was not known at all
until, under the impact of breaking through,
one high and hidden point shone.
Beyond that point, nothing is known.
So it is called Beginning.

"The enlightened will shine like the *zohar* of the sky,
and those who make the masses righteous
will shine like the stars forever and ever."

Zohar, concealed of the concealed, struck its aura.
The aura touched and did not touch this point.
Then Beginning emanated, building itself a glorious palace.
There it sowed the seed of holiness
to give birth for the benefit of the universe.

Zohar, sowing a seed of glory
like a seed of fine purple silk.

The silkworm wraps itself within, weaving itself a palace.
This palace is its praise, a benefit to all.

With Beginning, the unknown concealed one created the
 palace,
a palace called God.
The secret is: "With Beginning, _____ created God."

EIN SOF DOES NOT abide being known,
does not produce end or beginning.
Primordial Nothingness brought forth beginning and end.
Who is beginning?
The highest point, beginning of all,
the concealed one abiding in thought.
It also engenders end, the culmination of the word.
But there, no end.
No desires, no lights, no sparks in that Infinity.
All these lights and sparks are dependent on it but cannot
 comprehend.
The only one who knows, yet without knowing,
is the highest desire, concealed of all concealed,
 Nothingness.
And when the highest point and the world that is coming
 ascend,
they know only the aroma,
as one inhaling an aroma is sweetened.

ON THE DAY that Rabbi Shim'on was to leave the world,
while he was arranging his affairs,
the companions assembled at his house.
Present were Rabbi El'azar, his son, Rabbi Abba, and the
 other companions.
The house was full.
Rabbi Shim'on raised his eyes and saw that the house was
 filled.
He cried, and said,
"The other time I was ill, Rabbi Pinhas son of Ya'ir was in
 my presence.
I was already selecting my place in paradise next to Ahiyah
 of Shiloh
when they extended my life until now.
When I returned, fire was whirling in front of me;
it has never gone out.
No human has entered without permission.
Now I see it has gone out, and the house is filled."

While they were sitting
Rabbi Shim'on opened his eyes and saw what he saw;
fire whirled through the house.
Everyone left;
Rabbi El'azar, his son, and Rabbi Abba remained;
the other companions sat outside.
Rabbi Shim'on rose and laughed in delight.
He asked, "Where are the companions?"
Rabbi El'azar rose and brought them in.
They sat in front of him.
Rabbi Shim'on raised his hands and prayed a prayer.

Rejoicing, he said,
"Those companions who were present at the threshing house
 will convene here."
Everyone left;
Rabbi El'azar, his son, Rabbi Abba, Rabbi Judah,
Rabbi Yose, and Rabbi Hiyya remained.
Rabbi Abba sat behind him and Rabbi El'azar in front.
Rabbi Shim'on said, "Now is a time of favor.
I want to enter without shame into the world that is coming.
Holy words, until now unrevealed,
I want to reveal in the presence of Shekhinah,
so it will not be said that I left the world deficiently.
Until now they were hidden in my heart
as a password to the world that is coming.
I will arrange you like this:
Rabbi Abba will write; Rabbi El'azar, my son, will repeat;
the other companions will meditate within."

Rabbi Abba rose from behind him;
Rabbi El'azar, his son, sat in front.
Rabbi Shim'on said, "Rise, my son, for someone else will sit
 in that place."
Rabbi El'azar rose.
Rabbi Shim'on enwrapped himself and sat down.
He opened and said,
"It is so different now than at the threshing house.
There the Blessed Holy One and his chariots convened.
Now he is accompanied by the righteous from the Garden of
 Eden!
This did not happen before.
The Blessed Holy One wants the righteous to be honored
more than he wants himself to be honored.
So it is written concerning King Jeroboam.

He offered incense to idols and worshiped them;
yet the Blessed Holy One was patient.
But as soon as he stretched out his hand against Ido the
 prophet,
his hand dried up.
Not because he worshiped idols,
but because he threatened Ido the prophet.
Now the Blessed Holy One wants *us* to be honored
and all of them are coming with him!
Here is Rav Hamnuna Sava
surrounded by seventy of the righteous adorned with
 crowns,
each one dazzling with the luster of the Holy Ancient One,
concealed of all concealed.
He is coming to hear in joy these words I am about to speak."

Rabbi Shim'on was about to sit down, when he exclaimed:
"Look! Here is Rabbi Pinhas son of Ya'ir! Prepare his place!"
The companions trembled;
they got up and moved to the periphery of the house.
Rabbi El'azar and Rabbi Abba remained with Rabbi Shim'on.

Rabbi Shim'on said,
"In the threshing house, we were found to be:
all the companions speaking, I among them.
Now I alone will speak;
all are listening to my words, those above and those below.
Happy is my portion this day!"

Rabbi Shim'on opened and said,
" 'I am my beloved's, his desire is upon me.'
All the days that I have been bound to this world
I have been bound in a single bond with the Blessed Holy One.

That is why now his desire is upon me.
He and his holy entourage have come to hear in joy
 concealed words
and praise for the Holy Ancient One, concealed of all
 concealed.
Separate, separated from all, yet not separate.
For all is joined to it, and it is joined to all.
It is all!
Ancient of all ancients, concealed of all concealed.
Arrayed and not arrayed.
Arrayed to sustain all;
not arrayed, for it is not to be found.
Arrayed, it radiates nine lights,
blazing from it, from its array.
Those lights, sparkling, flashing, emanate in every direction.

"Until now these words were concealed,
for I was scared to reveal;
now they have been revealed!
Yet it is revealed before the Holy Ancient One
that I have not acted for my own honor
nor for the honor of my family
but rather so I will not enter his palace in shame.
Furthermore, I see that the Blessed Holy One
and all these righteous ones approve:
I see all of them rejoicing in this, my wedding celebration!
All of them are invited, in that world, to my wedding
 celebration.
Happy is my portion!"

Rabbi Abba said,
"When the Holy Spark, the High Spark, finished this word
he raised his hands, cried and laughed.
He wanted to reveal one word.

He said, 'I have been troubled by this word all my days
and now they are not giving me permission!'

"Summoning up his courage,
he sat and moved his lips and bowed three times.
No one could look at his place, certainly not at him.
He said, 'Mouth, mouth, you have attained so much!
Your spring has not dried up.
Your spring flows endlessly.
Of you it is written:
"A river issues from Eden."
"Like a spring whose waters do not fail."
Now I avow:
All the days I have been alive, I have yearned to see this day.
Now my desire is crowned with success.
This day itself is crowned.
Now I want to reveal words in the presence of the Blessed
 Holy One;
all those words adorn my head like a crown.
This day will not miss its mark like the other day,
for this whole day is mine.
I have now begun revealing words
so I will not enter shamefully into the world that is coming.
I have begun! I will speak!

'I have seen that all those sparks flash from the High Spark,
hidden of all hidden.
All are levels of enlightenment.
In the light of each and every level
there is revealed what is revealed.
All those lights are connected:
this light to that light, that light to this light,
one shining into the other,
inseparable, one from the other.

'The light of each and every spark,
called Adornments of the King, Crowns of the King—
each one shines into, joins onto the light within, within,
not separating without.
So all rises to one level,
all is crowned with one word;
no separating one from the other.
It and its name is one.

'The light that is revealed is called the Garment of the King.
The light within, within is a concealed light.
In that light dwells the Ineffable One, the Unrevealed.
All those sparks and all those lights sparkle from the Holy
 Ancient One,
concealed of all concealed, the High Spark.
Upon reflecting,
all those lights emanating—
there is nothing but the High Spark, hidden and
 unrevealed.' "

Rabbi Abba said,
"Before the Holy Spark finished, his words subsided.
I was still writing, intending to write more
but I heard nothing.
I did not raise my head:
the light was overwhelming; I could not look.
Then I started trembling.
I heard a voice calling:
'Length of days and years of life.'
I heard another voice:
'He asked you for life, and you granted it.'

"All day long, the fire in the house did not go out.
No one reached him; no one could:

light and fire surrounded him.
All day long, I lay on the ground and wailed.
After the fire disappeared
I saw the Holy Spark, Holy of Holies, leaving the world,
enwrapped, lying on his right, his face smiling.

"Rabbi El'azar, his son, rose, took his hands and kissed
 them.
As for me, I licked the dust from the bottom of his feet.
The companions wanted to cry but could not utter a sound.
Finally they let out a cry,
but Rabbi El'azar, his son, fell three times, unable to open his
 mouth.
Finally he opened and cried, 'Father! Father!' "

Rabbi Hiyya rose to his feet and said,
"Until now the Holy Spark has looked after us;
now is the time to engage in honoring him."
Rabbi El'azar and Rabbi Abba rose.
They carried him on a trundle made out of a gangplank—
Who has seen the companions' confusion?—
and the whole house was fragrant.
They lifted him onto his bed;
only Rabbi El'azar and Rabbi Abba attended him.
Truculent stingers and shield-bearing warriors from
 Sepphoris
came and beset them.
The people of Meron banded together and shouted,
for they feared he would not be buried there.

After the bed emerged from the house, it rose into the air;
fire blazed before it.
They heard a voice:
"Come and enter!

Assemble for the wedding celebration of Rabbi Shim'on!
'He shall enter in peace;
they shall rest on their couches.' "

As he entered the cave, they heard a voice from inside:
"This is the man who shook the earth, who made kingdoms
 tremble!
His Lord prides himself on him every day.
Happy is his portion above and below!
Many sublime treasures lie in store for him.
'Go to the end and take your rest;
you will rise for your reward at the end of days.' "

Eɪɴ Soꜰ is a place to which forgetting and oblivion pertain. Why? Because concerning all the sefirot, one can search out their reality from the depth of supernal wisdom. From there it is possible to understand one thing from another. However, concerning Ein Sof, there is no aspect anywhere to search or probe; nothing can be known of it, for it is hidden and concealed in the mystery of absolute nothingness. Therefore forgetting pertains to the comprehension of this place. So open your eyes and see this great, awesome secret. Happy is one whose eyes shine from this secret, in this world and the world that is coming!

Ayin:
Mystical
Nothingness

AYIN, NOTHINGNESS, is more existent than all the being of the world. But since it is simple, and every simple thing is complex compared with its simplicity, it is called Ayin.

•

THE INNER power is called Ayin because thought does not grasp it, nor reflection. Concerning this, Job said, "Wisdom comes into being out of ayin."

THE DEPTH of primordial being is called Boundless. Because of its concealment from all creatures above and below, it is also called Nothingness. If one asks, "What is it?" the answer is, "Nothing," meaning: No one can understand anything about it. It is negated of every conception. No one can know anything about it—except the belief that it exists. Its existence cannot be grasped by anyone other than it. Therefore its name is "I am becoming."

YOU MAY be asked: "How did God bring forth being from nothingness? Is there not an immense difference between being and nothingness?"

Answer as follows: "Being is in nothingness in the mode of nothingness, and nothingness is in being in the mode of being." Nothingness is being, and being is nothingness. The node of being as it begins to emerge from nothingness into existence is called faith. For the term "faith" applies neither to visible, comprehensible being, nor to nothingness, invisible and incomprehensible, but rather to the nexus of nothingness and being. Being does not stem from nothingness alone but rather, from being and nothingness together. All is one in the simplicity of absolute undifferentiation. Our limited mind cannot grasp or fathom this, for it joins infinity.

THE TEN SEFIROT are the secret of existence, the array of wisdom, by which the worlds above and below were created. Corresponding to this secret are the ten utterances by which the world was created, and the ten commandments, which epitomize the holy Torah. Indeed, the ten sefirot constitute the secret of divine existence; they comprise above and below, every single thing. They are ancient and concealed. From them emerges the mystery of the supernal chariot—a matter concealed and sealed for those who discover knowledge.

Keter Elyon, highest crown, is called the pure ether that cannot be grasped. It is the sum of all existence, and all have wearied in their search for it. One should not ponder this place. It is secretly named Ein Sof—Infinity—for it engenders everything that is. The belt of the wise is burst by this mysterious cause of causes.

Arouse yourself to contemplate, to focus thought, for God is the annihilation of all thoughts, uncontainable by any concept. Indeed, since no one can contain God at all, it is called Nothingness, Ayin. This is the secret of the verse, "Wisdom comes into being out of ayin." Anything sealed and concealed, totally unknown to anyone, is called ayin, meaning that no one knows anything about it. Similarly, no one knows anything at all about the human soul; she stands in the status of nothingness, as it is written: "The superiority of the human over the beast is ayin." By means of this soul, the human being ascends higher than all other creatures and attains the glory of Ayin.

At times, a breeze blows by, delighting the heart and the mind. You do not know what it is or why; it cannot be grasped. Similarly, when this sefirah is aroused, it radiates and sparkles and cannot be grasped at all.

How precious it is to know that God generates all of existence. From one bit of existence, the soul can perceive the existence of God, which has neither beginning nor end. The highest crown is not a beginning, yet from there emerged the point of concealment, the head of all levels, of all the other mirrors, the beginning of all existence. If you have eyes to see, you can search this matter meticulously and waft the mind in imagination to the secret power of this sefirah. Contemplate, understand, dedicate yourself to know that this sefirah returns to its original state. To whom does it belong?

The beginning of existence is the secret concealed point, primordial wisdom, the secret conceptual point. This is the beginning of all the hidden things, which spread out from there and emanate, according to their species. From a single point you can extend the dimensions of all things. Similarly, when the concealed arouses itself to exist, at first it brings into being something the size of the point of a needle; from there it generates everything.

Contemplate this: When the emanation was emanated out of Ayin, all things and all sefirot were dependent on thought. God's secret existence emerged from this single point. That which abides in thought yet cannot be grasped is called wisdom: Hokhmah. What is the meaning of Hokhmah? *Hakkeh mah.* Since you can never grasp it, hakkeh, "wait," for mah, "what" will come and what will be. This is the sublime, primordial wisdom emerging out of Ayin.

THINK OF yourself as Ayin and forget yourself totally. Then you can transcend time, rising to the world of thought, where all is equal: life and death, ocean and dry land. Such is not the case if you are attached to the material nature of this world. If you think of yourself as something, then God cannot clothe himself in you, for God is infinite. No vessel can contain God, unless you think of yourself as Ayin.

THE ESSENCE of serving God and of all the *mitsvot* is to attain the state of humility, that is, to understand that all your physical and mental powers and your essential being depend on the divine elements within. You are simply a channel for the divine attributes. You attain this humility through the awe of God's vastness, through realizing that "there is no place empty of it." Then you come to the state of Ayin, the state of humility. You have no independent self and are contained in the Creator. This is the meaning of the verse: "Moses hid his face, for he was in awe." Through his experience of awe, Moses attained the hiding of his face, that is, he perceived no independent self. Everything was part of divinity.

The
Ten Sefirot

RABBI ISHMAEL said, "I saw the King of kings of kings, the Holy One, blessed be he, sitting on a throne, high and exalted, with his soldiers standing before him, on his right and on his left. The Prince of the Countenance, Metatron, spoke to me.

"What is the measure of the stature of the Holy One, blessed be he, concealed from all creatures?

"The soles of his feet fill the entire universe; their height is 30 million parasangs. From the sole of his foot to his ankle is 10 million parasangs. From his ankle to his knees is 190 million parasangs. From his knees to his thighs is 120 million parasangs. From his thighs to his neck is 240 million parasangs. His neck extends 130 million parasangs. The circumference of his head is over 3 billion parasangs—something the mouth cannot express, nor the ear hear. His beard is 11,500 parasangs. His face and cheeks are like spirit and soul, which no soul can perceive.

"His body is like aquamarine. His radiance scintillates, awesome from within the darkness. Dense clouds surround him. All the angels of the Presence pour themselves out before him as water pouring from a pitcher.

"His tongue extends from one end of the universe to the other. The width of his forehead is 130 million parasangs; on it are written seventy letters. The black of his right eye is 11,500 parasangs, and so on the left. From his right shoulder to his left shoulder is 160 million parasangs. From his right arm to his left arm is 120 million parasangs. His arms are folded. The fingers on each of his hands are 150 million parasangs, each finger 30 million. His palms are each 40 million parasangs. His toes are 100 million parasangs, each one 20 million. Therefore he is called 'the great, mighty, and awesome God.'

"But then Metatron told me how to calculate the parasangs. What is their measure? Each parasang is three miles, each mile is 10,000 cubits, each cubit is two spans—measured according to God's span, which spans the entire universe."

YAH YHVH TSEVA'OT engraved thirty-two wondrous paths of wisdom, creating the universe in three ciphers: boundary, language, and number.

> Ten *sefirot belimah*—numerals of nothingness, entities of emptiness—and twenty-two elemental letters.

> Ten sefirot belimah, corresponding to the ten fingers, five opposite five, with the covenant of oneness precisely in the middle, in the word of the tongue and in circumcision.

> Ten sefirot belimah, ten and not nine, ten and not eleven. Understand in wisdom, be wise in understanding. Examine them, explore them. Know, contemplate, and visualize. Establish the matter thoroughly, and restore the Creator to his abode. Their measure is ten, yet infinite.

> Ten sefirot belimah. Bridle your mind from imagining, your mouth from speaking. If your mind races, return to the place you departed. Remember what is written: "The creatures darting to and fro." Concerning this a covenant has been made.

> Ten sefirot belimah. Their measure is ten, yet infinite. Their end is embedded in their beginning, their beginning in their end, like a flame joined to a burning coal. Know, contemplate, and visualize that the Creator is one, without a second. Before one what can you count?

> Ten sefirot belimah. Their measure is ten, yet infinite. Depth of beginning, depth of end, depth of good, depth of evil, depth of above, depth of below, depth of east, depth of west, depth of north, depth of south. God alone rules them all from his holy abode to eternities of eternity.

> Ten sefirot belimah. A vision flashing like lightning. Their limit has no end. God's word surges through them.

I AM the one who planted this tree for all the world to delight in. With it I spanned the All, calling it All, for all depends on it, all emanates from it, all need it, all gaze upon it and await it. From here souls fly forth in joy.

Alone I was when I made it. When I spread out my earth, in which I planted and rooted this tree—giving them joy in one another, rejoicing along with them—who was with me? To whom could I reveal this secret of mine?

ONE PILLAR extends from earth to heaven. Its name is Righteous One, named for the righteous. If there are righteous people in the world, the pillar is strengthened; if not, it is weakened. It upholds the entire world, as it is written: "The righteous one is the foundation of the world." If it weakens, the world cannot endure. So if the world contains just one righteous person, that person sustains the world.

THE RIGHTEOUS ONE stands gazing out at humanity. When he sees human beings engaged in Torah and mitsvot, seeking to refine themselves, to conduct themselves in purity, then the Righteous One expands, filling himself with all kinds of flowing emanation from above, to pour into Shekhinah, the divine presence, in order to reward those purifying themselves, those cleaving to Torah and mitsvot. Thus, the entire world is blessed by those righteous humans, and Shekhinah is likewise blessed through them.

But if, God forbid, humans defile themselves by distancing themselves from Torah and mitsvot, by perpetrating evil, injustice, and violence, then the Righteous One stands to gaze at what they have done. When he sees, he gathers and contracts himself, ascending higher and higher. Then the flow of all the channels ceases, and Shekhinah is left dry and empty, lacking all good.

One who understands this secret understands the immense power a human has to build and to destroy. Now, come and see the power of the righteous: they can unite all the sefirot, harmonizing the upper and the lower worlds.

THE SECRET of Sabbath: She is Sabbath.
United in the secret of one
to draw upon her the secret of one.

When Sabbath enters she is alone,
separated from the Other Side, all judgments removed
 from her.
Basking in the oneness of holy light,
she is crowned over and over to face the holy King.
All powers of wrath and masters of judgment flee from her.
There is no power in all the worlds aside from her.
Her face shines with a light from beyond;
she is crowned below by holy people,
all of whom are crowned with new souls.
Then the beginning of prayer,
blessing her with joy, with beaming faces.

THE TRUE ESSENCE of God cannot be grasped by anyone but God. There is not a single angel in heaven who knows God's location—and certainly not God's true essence. Don't you realize what the angels say: "Blessed be the presence of YHVH from his place"? In other words, wherever God's place may be. If the celestial creatures do not know, then how could earthly creatures ever know?

So all those descriptions that we read in the Torah, of God's hand, foot, ear, and eye—what do they mean? Know and believe that although those descriptions indicate God's true being, no creature can know or contemplate the essence of what is called "hand," "foot," "ear," or the like. Though we are made in the divine image and likeness, do not imagine that the divine eye is actually in the form of an eye or the divine hand in the form of a hand. Rather, these are inner—innermost—aspects of the divine reality, from which the fountain flows to all creatures through the divine decree. But the essence of the divine hand is not like the essence of the human hand, nor is their form the same, as it is written: "To whom can I be compared?"

Know and understand that there is no similarity in substance or structure between God and us—except for the intention of the forms of our organs and limbs, which are fashioned as symbols of hidden, supernal realities. The mind cannot know these realities directly; it can only be reminded of them. As when one writes "Reuben son of Jacob." The form of these letters is not the form, structure, and essence of the real Reuben son of Jacob but simply a mnemonic device. "Reuben son of Jacob" is a symbol of the particular entity called by that name.

Since God wanted to purify us, he created in the human body various organs and limbs—hidden and revealed—as symbols of the divine structure. If one succeeds in purifying a particular organ or limb, it becomes a throne for the sublime, inner reality called by that name: "eye," "hand," or any other one.

THE PALM TREE OF DEBORAH

IMITATE YOUR CREATOR. Then you will enter the mystery of the supernal form, the divine image in which you were created. If you resemble the divine in body but not in action, you distort the form. People will say of you: "A lovely form whose deeds are ugly." For the essence of the divine image is action. What good is it if your anatomy corresponds to the supernal form, while your actions do not resemble God's? So imitate the acts of Keter, the thirteen qualities of compassion alluded to by the prophet Micah: "Who is a God like you, delighting in love? You will again have compassion upon us. You will hurl all our sins into the depths of the sea."

You should desire the well-being of your fellow creature, eying his good fortune benevolently. Let his honor be as precious to you as your own, for you and your fellow are one and the same. That is why we are commanded: "Love your neighbor as yourself." You should desire what is right for your fellow; never denigrate him or wish for his disgrace. Just as God desires neither our disgrace nor our suffering, because of our close relationship with him, so you should not desire someone else's disgrace, suffering, or ruin. You should feel as bad for such suffering as if it were your own. Similarly, rejoice over another's good fortune as if you were basking in it.

God does not behave as a human being normally behaves. If one person angers another, even after they are reconciled the latter cannot bring himself to love the one who offended him as he loved him before. Yet if you sin and then return to God, your status is higher. As the saying goes, "Those who return to God occupy a place where even the completely righteous cannot stand." So when you return to God, and God restores the divine presence to you, his love for you is not the same as before but all the greater. This is the meaning of:

THE TEN SEFIROT 83

"You will again have compassion upon us." God will increase his compassion, mending us, bringing us closer.

This is how you should behave toward your fellow human being. Do not bear a grudge from the anger you felt. When you see that he wants to make up, be much more compassionate and loving than before. Say to yourself: "He is like one of those who return to God, unrivaled by even the completely righteous." Cultivate a more intimate relationship with him than with those who have been completely righteous with you, who have never offended you.

These are some of the qualities by which you resemble your Creator. The sublime qualities of compassion have a precious characteristic: just as you conduct yourself below, so are you worthy of opening the corresponding sublime quality above. Exactly as you behave, so it emanates from above. You cause that quality to shine in the world.

THE QUALITY of humility includes all qualities, since it pertains to Keter. Although Keter transcends all the other qualities, it does not exalt itself; on the contrary, it descends, constantly gazing below. Its emanator constantly gazes into it, bestowing goodness, while it gazes at those beneath.

God nourishes everything, from the horned buffalo to nits, disdaining no creature—for if he disdained creatures due to their insignificance, they could not endure for even a moment. Rather, he gazes and emanates compassion upon them all. So should you be good to all creatures, disdaining none. Even the most insignificant creature should assume importance in your eyes; attend to it. Do good to whomever needs your goodness.

YOUR FOREHEAD should not be tense at all but rather always resemble the forehead of the Will, so that you soothe everyone. Even if you come across angry people, soothe and calm them with your goodwill. For the forehead of the Will

constantly accepts and soothes the harsh powers, reintegrating them. So should you soothe those overwhelmed by anger. Induce them with goodwill, drawing on great wisdom to extinguish their anger before it transgresses the boundary and causes damage, God forbid. Model yourself on the Will, which emanates from the wondrous wisdom in the forehead of the Ancient One, from where it soothes everything. Derive the power to be genial with others. If your character is somewhat harsh, people will not be soothed. This is why the Mishnah teaches: "If the spirit of people delights in someone, so does the spirit of God."

Your ears should always be tuned to hear the good, while rumors and gossip should never be let in, according to the secret of sublime listening. There, no harsh shouting enters, no tongue of evil leaves a blemish. So listen only to positive, useful things, not to things that provoke anger.

Your eyes should not gaze at anything disgraceful. Rather, they should always be open to notice those who suffer, to be compassionate toward them as much as possible. When you see a poor person suffering, do not close your eyes in the slightest. On the contrary, keep him in mind as much as you can; arouse compassion for him—from God and from people.

Your face should always be shining. Welcome each person with a friendly countenance. For with regard to Keter Elyon, the supernal crown, it is said: "In the light of the king's face is life." No redness or harsh judgment gains entrance there. So, too, the light of your face should never change; whoever looks at you will find only joy and a friendly expression. Nothing should disturb you.

Your mouth should produce nothing but good. The words you speak should be Torah and an expression of goodwill. Never generate angry or ugly words, curses, or nonsense. Let your mouth resemble the upper mouth, which is never closed, never silent, never withholding the good. Speak positively, always with benevolent words.

All of these good qualities gather under the banner of humility, each one constituting a limb in Keter above. When you wish to draw near to the upper worlds, to resemble God, to open the fountains to those beneath, you must become proficient in these chapters.

It is impossible, of course, to conduct yourself according to these qualities constantly. Accustom yourself to them little by little. The essential quality to attain, the key to them all, is humility, for this is the very first aspect of Keter, under which all the rest are subsumed. If you constantly strive to attain this quality, all the others follow in its wake. For the first quality of Keter is that it considers itself as nothing in the face of its emanator. So, too, you should consider yourself as actually nothing. This will lead to the attainment of all the good qualities.

I have found an effective potion for the cure of pride. This consists of training yourself to do two things. First, respect all creatures, recognizing in them the sublime nature of the Creator, who fashions human beings in wisdom and whose wisdom inheres in each created thing. Second, train yourself to bring the love of your fellow human beings into your heart, even the wicked, as if they were your brothers and sisters, even more, until the love of all human beings is firm in your heart. Love even the wicked, thinking: "I wish that they were righteous, turning back to God, making themselves desirable to the Omnipresent." In this way your heart will turn toward the good, and you will train yourself to contemplate the various good qualities.

How should you train yourself in the quality of Hokhmah, Wisdom?

Supernal wisdom, though concealed and transcendent, spreads over every single thing that exists. Concerning this, it is said: "How manifold are your works, O God! In wisdom

you have made them all." So should your wisdom be accessible to all. Teach people what will be useful to them, according to each one's capacity, pouring out to each as much wisdom as you can. Don't let anything deter you.

Wisdom has two faces. The upper face turns toward Keter; not gazing below, it receives from above. The second face, the lower one, turns below to gaze at the sefirot, emanating its wisdom to them. You too should have two facets. The first is your aloneness with God, to increase and refine your wisdom. The second, to teach others some of the wisdom that God has poured out upon you. As Wisdom emanates to each sefirah according to its dimensions and need, so should you emanate to each person according to the dimensions of his mind, whatever he can handle, what addresses his needs. Be careful not to give more than the mind of the recipient can hold, to prevent any mishap, just as the highest sefirah does not exceed the limits of its recipient.

Let your compassion extend to all creatures, neither despising nor destroying any of them. For Wisdom spreads over all created things: mineral, vegetable, animal, and human. Each was created in Wisdom. Do not uproot anything that grows, unless it is necessary. Do not kill any living creature, unless it is necessary.

How SHOULD you train yourself in the quality of Binah, Understanding?

By returning to God. Nothing is more important, for this corrects every flaw. As Binah, Understanding, sweetens all powers of judgment, neutralizing their bitterness, so should you return to God and correct each flaw. If you meditate on returning every day, you stimulate Binah to illumine each day. In consequence all your days join in returning, that is, you integrate yourself within Binah, who is called Returning. Each day of your life is adorned with the mystery of supernal return.

Do not say that returning is good only for the holy portion within you; the evil portion, too, is sweetened, in the manner of this quality. Do not think that because you incline toward evil there is no remedy. This is false. If you do well, rooting yourself in Returning, you can ascend there through the goodness rooted there. For the root of every supernal bitterness is sweet; you can enter through this root and make yourself good. Thereby you transform the bad deeds themselves into good; your intentional sins turn into merits. The misdeeds you committed have been accusing you from the Left Side. Once you return completely, you raise those deeds and root them above. Those accusers are not annihilated but ameliorated, rooted in holiness.

How SHOULD you train yourself in the quality of Hesed, Love? The basic way you enter the mystery of Hesed is by loving God to the extreme, not abandoning devotion for any reason at all, since nothing attracts you in the least, compared to loving God. So first attend to the demands of your devotion; the remainder of your time is for whatever else you need.

"Who is a *hasid*? One who acts in love toward God." In expressing love to creatures here below, intend that you are mending up above, after the same pattern. You thereby bestow love on God.

Creation

God said, "Let there be light!" and there was light.
God saw how good the light was
and God separated the light from the darkness.

Rabbi Isaac said,
"The light created by God in the act of Creation
flared from one end of the universe to the other
and was hidden away,
reserved for the righteous in the world that is coming,
as it is written:
'Light is sown for the righteous.'
Then the worlds will be fragrant, and all will be one.
But until the world that is coming arrives,
it is stored and hidden away."

Rabbi Judah responded,
"If the light were completely hidden,
the world would not exist for even a moment!
Rather, it is hidden and sown like a seed
that gives birth to seeds and fruit.
Thereby the world is sustained.
Every single day, a ray of that light shines into the world,
keeping everything alive;
with that ray God feeds the world.
And everywhere that Torah is studied at night
one thread-thin ray appears from that hidden light
and flows down upon those absorbed in her.
Since the first day, the light has never been fully revealed,
but it is vital to the world,
renewing each day the act of Creation."

WHEN POWERFUL LIGHT is concealed and clothed in a garment, it is revealed. Though concealed, the light is actually revealed, for were it not concealed, it could not be revealed. This is like wishing to gaze at the dazzling sun. Its dazzle conceals it, for you cannot look at its overwhelming brilliance. Yet when you conceal it—looking at it through screens—you can see and not be harmed. So it is with emanation: by concealing and clothing itself, it reveals itself.

●

WITH THE APPEARANCE of the light, the universe expanded.
With the concealment of the light, the things that exist were
 created in all their variety.
This is the secret of the act of Creation.
One who understands will understand.

WHEN A glassblower wants to produce glassware, he takes an iron blowpipe, hollow as a reed from one end to the other, and dips it into molten glass in a crucible. Then he places the tip of the pipe in his mouth and blows, and his breath passes through the pipe to the molten glass attached to the other end. From the power of his blowing, the glass expands and turns into a vessel—large or small, long or wide, spherical or rectangular, whatever the artisan desires.

So God, great, mighty, and awesome, powerfully breathed out a breath, and cosmic space expanded to the boundary determined by divine wisdom, until God said, "Enough!"

•

HOW DID God create the world? Like a person taking a deep breath and holding it, so that the small contains the large. Similarly God contracted his light to a divine handbreadth, and the world was left in darkness. In the darkness God carved cliffs and hewed rocks to clear wondrous paths of wisdom.

WISDOM IS the end of what you can ponder in thought, for Keter, the highest sefirah, fills more than the mind can conceive. It contracted the essence of its presence into a handbreadth, and darkness appeared over everything, for the absence of light is darkness. Then from the source of all, it emanated the bright light of Wisdom in thirty-two paths, each path penetrating the darkness. With them the engraver engraved the darkness.

•

BEFORE THE creation of the world, Ein Sof withdrew itself into its essence, from itself to itself within itself. It left an empty space within its essence, in which it could emanate and create.

WHEN THE supernal emanator wished to create this material universe, it withdrew its presence. At first Ein Sof filled everything. Now, still, even an inanimate stone is illuminated by it; otherwise the stone could not exist at all—it would disintegrate. The illumination of Ein Sof clothes itself in garment upon garment.

At the beginning of creation, when Ein Sof withdrew its presence all around in every direction, it left a vacuum in the middle, surrounded on all sides by the light of Ein Sof, empty precisely in the middle. The light withdrew like water in a pond displaced by a stone. When a stone is dropped in a pond, the water at that spot does not disappear—it merges with the rest. So the withdrawn light converged beyond, and in the middle remained a vacuum. Then all the opacity and density of judgment within the light of Ein Sof—like a drop in the ocean—was extracted. Descending into the vacuum, it transformed into an amorphous mass, surrounded in every direction by the light of Ein Sof. Out of this mass emanated the four worlds: emanation, creation, formation, and actualization. For in its simple desire to realize its intention, the emanator relumined the mass with a ray of the light withdrawn at first—not all of the light, because if it had all returned, the original state would have been restored, which was not the intention.

To fashion pottery, the potter first takes an unformed mass of clay and then puts his hand inside the mass to shape it. So the supernal emanator put its hand into the amorphous mass, that is, a ray of light returned from above. As this light began to enter the mass, vessels were formed. From the purest light, Keter; next, Hokhmah; then, Binah; and so on through all ten

sefirot. Since Keter was the purest and clearest of all the vessels, it could bear the light within it, but Hokhmah and Binah, though more translucent than those below, were not like Keter. Not having its capacity, their backs broke, and they fell from their position. As the light descended further, six points appeared—six fragments of what had been one point of light. Thus the vessels shattered. Their spiritual essence—the light—ascended back to the mother's womb, while the shattered vessels fell to the world of creation.

When the light emanated once again—regenerated, arrayed anew— it extended only to the end of the world of emanation. "Emanation" denotes this extension of the light of Ein Sof during the time of regeneration. Emanation consists of five visages. These visages are reconfigurations of the points of light, capable now of receiving the light, so that no shattering occur, as at first. Below these visages the light of Ein Sof appears only through a screen. As when you sit in the shade: though the sun does not shine on you directly, it illuminates the shaded area. In a similar manner, the light of Ein Sof illuminates the world of creation through a screen, indirectly.

THE SUPERNAL vacuum is like a field, in which are sown ten points of light. Just as each grain of seed grows according to its fertile power, so does each of these points. And just as a seed cannot grow to perfection as long as it maintains its original form—growth coming only through decomposition—so these points could not become perfect configurations as long as they maintained their original form but only by shattering.

TRACES OF the light adhered to the shards of the shattered vessels. This may be compared to a vessel full of oil. If it breaks and the oil spills out, a bit of the liquid adheres to the shards in the form of drops. Likewise in our case, a few sparks of light adhered. When the shards descended to the bottom of the world of actualization, they were transformed into the four elements—fire, air, water, and earth—from which evolved the stages of mineral, vegetable, animal, and human. When these materialized, some of the sparks remained hidden within the varieties of existence. You should aim to raise those sparks hidden throughout the world, elevating them to holiness by the power of your soul.

THE WORLD could be created only by virtue of the action of the righteous, the arousal of those below. So God contemplated the good deeds of the righteous—yet to be created—and this act of thinking was enough to actualize the thought. God drew forth light from within himself and delighted himself with holy people, like those who would eventually be. This joy engendered undulation, greater delight. In the bliss of contemplating the righteous, of imagining holy people—in this fluctuation, the power to create was born.

AN EPIPHANY enables you to sense creation not as something completed, but as constantly becoming, evolving, ascending. This transports you from a place where there is nothing new to a place where there is nothing old, where everything renews itself, where heaven and earth rejoice as at the moment of Creation.

Letters
of the
Alphabet

TWENTY-TWO elemental letters. God engraved them, carved them, weighed them, permuted them, and transposed them, forming with them everything formed and everything destined to be formed.

Twenty-two elemental letters. God set them in a wheel with 231 gates, turning forward and backward. How did God permute them? *Alef* with them all, all of them with alef; *bet* with them all, all of them with bet; and so with all the letters, turning round and round, within 231 gates. Thus all that is formed, all that is spoken emerges from one name.

Out of chaos God formed substance, making what is not into what is. He hewed enormous pillars out of ether that cannot be grasped.

When Abraham our father, peace unto him, gazed—looking, seeing, probing, understanding, engraving, carving, permuting, and forming—he succeeded in creation. Immediately God manifested to him, embracing him, kissing him on the head, calling him "Abraham, my beloved."

Prepare to meet your God. Prepare to devote your heart. Purify your body and select a special place where no one in the world can hear your voice. Be totally alone. Sit in one spot in the room or the loft, and do not reveal your secret to anyone. If you can, do this by day, even for a little while, but the best way is to do it at night. As you prepare to speak with your Creator, to seek the revelation of his power, be careful to empty your mind of all mundane vanities. Wrap yourself in your *tallit* and put *tefillin* on your head and your hand so that you will be filled with the awe of Shekhinah, who is with you at this moment. Wear clean garments, all white if you can. All this helps immensely in focusing your awe and love. If it is night, light many candles, until your eyes shine brightly.

Then take hold of ink, pen, and tablet. Realize that you are about to serve your God in joy. Begin to combine letters, a few or many, permuting and revolving them rapidly until your mind warms up. Delight in how they move and in what you generate by revolving them. When you feel within that your mind is very, very warm from combining the letters, and that through the combinations you understand new things that you have not attained by human tradition nor discovered on your own through mental reflection, then you are ready to receive the abundant flow, and the abundance flows upon you, arousing you again and again.

Now turn your thoughts to visualizing the Name and its supernal angels, imagining them as if they were human beings standing or sitting around you, with you in the middle like a messenger about to be sent on a royal mission, waiting to hear about it from their lips, either from the king himself or from one of his ministers. Having imagined this vividly, prepare your mind and heart to understand the many things

about to be conveyed to you by the letters being contemplated within you. Meditate on them as a whole and in all their detail, like one to whom a parable, a riddle, or a dream is being told, or like one perusing a book of wisdom, pondering a passage beyond his grasp. Interpret what you hear in an uplifting manner, approximating it as best you can. Based on what you understand of it, evaluate yourself and others. All this will happen after you fling the tablet from your hands and the pen from your fingers, or after they fall by themselves due to the intensity of your thoughts.

Realize that the stronger the mental flow, the weaker will become your organs and limbs. Your entire body will begin to tremble violently. You will think that you are about to die because your soul, overjoyed at what she has attained, will depart from your body. Consciously choose death over life, knowing that such death affects only the body and that thereby the soul lives eternally. Then you will know that you are capable of receiving the flow. If you then wish to honor the glorious Name by serving it with the life of body and soul, hide your face, fear to gaze at God, and come no closer, like Moses at the burning bush. Return to the physical dimension; rise, eat and drink a little, inhale a fragrant aroma. Return your spirit to its sheath until another time. Rejoice in what you have, and know that God loves you.

WHY DO we utter letters and move them around? I, a fledgling, will tell you what I experienced. Know, my friends, that from the beginning I felt a desire to study Torah. I learned parts of it and some of the rest of the Bible. But I found no one to guide me in the study of Talmud—not for any lack of teachers, but because I longed to be home, to enjoy being with my father and mother. Finally, God gave me strength to search for Torah. I went out, searched, and found. For several years I studied Talmud abroad. Still the fire of Torah burned within me—though I could not sense it.

I returned to my native land, and God brought me together with a Jewish philosopher with whom I studied some of Moses Maimonides' *Guide of the Perplexed*. This only added to my desire. I began to explore logic and natural science; this wisdom tasted sweet for, as you know, nature attracts nature. God is my witness: If I had not previously acquired strength of faith through the little I had learned of Torah and Talmud, many of the mitsvot would have been ruined for me—even though the fire of pure intention blazed in my heart.

What this teacher revealed on the path of philosophy was inadequate. Then God had me meet a divine man, a kabbalist, who taught me the outlines of Kabbalah. Nevertheless, because of my smattering of natural science, the path of Kabbalah seemed to me nearly impossible.

Then my teacher said to me, "My son, why do you deny something you have not tried? You should try it. If you do not discover anything—and you are not perfect enough to attribute the fault to yourself—then say nothing is there." Wherever he guided me, he would always define the matter for me in scientific terms—to sweeten it for me, so that my rational mind would accept it and I could enter enthusiastically.

I reasoned as follows: I have much to gain here and nothing to lose. If I discover something, I have gained; if not, what I already have will still be mine. So I placed myself on the path, and he showed me how to permute the letters of the alphabet, transpose them, play with their numerical values, and the other techniques outlined in *Sefer Yetsirah*. He let me explore each path for two weeks—until each form was engraved in my heart. So he drew me on for about four months. Then he commanded me to erase everything. He said to me, "My son, the intention is not to grasp any finite form—even the highest. Rather, this is the path of the names: Their intrinsic value is proportional to their degree of incomprehensibility. The less comprehensible, the higher. Eventually you will reach an energy that is not in your control; rather your mind and thought are in its control."

I replied, "If this path is incomprehensible, then why do you compose books combining natural science with the divine names?"

He said, "For you and those like you among the philosophizers, to attract your human minds naturally. Perhaps this attraction will bring you to the knowledge of the Name."

My mind did not accept it. But after about two months of meditation, my thought had been stripped, and I became aware of something sublime arising within. I set my mind to combine the letters at night, conducting them in contemplation—just a little differently than I do now. I continued this for three nights without telling him. The third night, after midnight, I was sitting with the quill in my hand and the paper on my knees. I nodded off—then suddenly saw the candle about to go out, as often happens when you wake from a nap. I rose to trim the candle, and I saw that the light persisted. I was amazed. As I gazed and contemplated, the light seemed to be issuing from me. I said, "I don't believe it." I walked throughout the house—and look, the light moves

with me! I lay down on the couch and covered myself. Look, the light is with me still!

Those who know a little about this—and especially those to whom something has been revealed experientially—will rejoice in what I have written and find it fitting. But their difficulty will be that I have revealed all this explicitly. As for me, God knows and is my witness! My intention is for the sake of heaven. I wish that every person in our holy nation excelled me in this, that everyone was purer than I. Then, perhaps, things unknown to me could be revealed. For God, who is truly one, teaches all who are ready to receive—freely and in love. Since God desires us to imitate the divine perfectly, I cannot bear not to lavish upon another what God has lavished upon me. That is why I had to tell the story of my experience, because the only genuine proof of this wisdom is experience itself.

THE DIVINE mind pours upon us constantly, emanating its sacred abundance to us, for more than the calf wants to suck, the cow wants to suckle. Let us do good deeds and engage in aloneness—sitting in a loft with books, myrtle, ink, pen, paper, and tablet, to combine the letters and draw the divine mind into us.

When you fulfill the conditions of aloneness in your room, you will attain the flowing abundance of the six sefirot emanating to the diadem, whose splendor dwells within your soul, and the abundance of the three upper sefirot, drawing them to the diadem and into your soul. These abundant flows, hidden from the senses, will appear to the eye of your mind as cascading water; they are nothing but sparks of light—white, pure, and dazzling—emanating to the diadem, from there to Moses, and from there to the mind within your soul. Enjoy this abundant rain. Offer thanks to God with neither speech nor thought. As it says in *Sefer Yetsirah*, "If your mind races, return to the place," return to where you were before the thought. Return to the site of oneness.

Mind,
Meditation,
and
Mystical
Experience

WHATEVER ONE implants firmly in the mind becomes the essential thing. So if you pray and offer a blessing to God, or if you wish your intention to be true, imagine that you are light. All around you—in every corner and on every side—is light. Turn to your right, and you will find shining light; to your left, splendor, a radiant light. Between them, up above, the light of the Presence. Surrounding that, the light of life. Above it all, a crown of light—crowning the aspirations of thought, illumining the paths of imagination, spreading the radiance of vision. This light is unfathomable and endless.

AN EXTRA SPIRIT

YOU FEEL an extra spirit—arousing you, flowing over your entire body, bringing pleasure. It seems as if fine balsam oil has been poured over you from your head to your feet—once, maybe more. You are overjoyed, in delight and trembling: the soul in delight, the body in trembling. Like a rider racing a horse: the rider is joyful and exuberant, while underneath, the horse quivers.

Say to Wisdom, "You are my sister."
Join thought to divine wisdom, so she and he become one.

●

Taste and see that God is good.
The soul will cleave to the divine mind, and the divine mind will cleave to her. For more than the calf wants to suck, the cow wants to suckle. She and the divine mind become one, like pouring a jug of water into a gushing spring: all becomes one.

THE MIRROR OF THOUGHT

THOUGHT IS like a mirror. One looking at it sees his image inside and thinks that there are two images, but the two are really one.

•

THE ANNIHILATION OF THOUGHT

THOUGHT RISES to contemplate its own innerness until its power of comprehension is annihilated.

•

BEYOND KNOWING

THE INNER, subtle essences can be contemplated only by sucking, not by knowing.

THOUGHT REVEALS itself only through contemplating a little without content, contemplating sheer spirit. The contemplation is imperfect: you understand—then you lose what you have understood. Like pondering a thought: the light of that thought suddenly darkens, vanishes; then it returns and shines—and vanishes again. No one can understand the content of that light. It is like the light that appears when water ripples in a bowl: shining here, suddenly disappearing—then reappearing somewhere else. You think that you have grasped the light, when suddenly it escapes, radiating elsewhere. You pursue it, hoping to catch it—but you cannot. Yet you cannot bring yourself to leave. You keep pursuing it.

It is the same with the beginning of emanation. As you begin to contemplate it, it vanishes, then reappears; you understand—and it disappears. Even though you do not grasp it, do not despair. The source is still emanating, spreading.

MENTAL ATTACHMENT

IN MEDITATION, everything depends on thought. If your thought becomes attached to any created thing—even something unseen or spiritual, higher than any earthly creature—it is as if you were bowing down to an idol on your hands and knees.

IMAGINATION

THE FIERCE power of imagination is a gift from God. Joined with the grandeur of the mind, the potency of inference, ethical depth, and the natural sense of the divine, imagination becomes an instrument for the holy spirit.

ONE WHO descends from the root of roots to the form of forms must walk in multiplicity. One who ascends from the form of forms to the root of roots must gather the multiplicity, for the highest form unites them all, and the root extends through every form that arises from it at any time. When the forms are destroyed, the root is not destroyed.

WHOEVER ATTAINS the mystery of cleaving to God will attain the mystery of equanimity, and if one attains the mystery of equanimity, one will attain the mystery of aloneness. Having attained the mystery of aloneness, this person will attain the holy spirit. And from there, prophecy, and he will prophesy the future.

As for the mystery of equanimity, Rabbi Avner told me the following:

A lover of wisdom came to one who secluded himself in meditation and asked to be accepted as one of them. The master of meditation replied, "My son, may you be blessed from heaven, for your intention is good. But let me know: Have you attained equanimity or not?"

He responded, "Master, clarify your words."

He explained, "My son, if one person honors you and another humiliates you, are the two equal in your eyes or not?"

He answered, "By the life of your soul, my master! I do feel pleasure and satisfaction from the one who honors me and pain from the one who humiliates me—but I am not vengeful nor do I bear a grudge."

The master said, "My son, go away in peace. For as long as you have not attained equanimity and still feel humiliation from something done to you, you are not ready for your thought to be linked on high. You are not ready to come and seclude yourself in meditation. But go and humble your heart further, genuinely, until you attain equanimity. Then you can experience aloneness."

THOSE WHO practice aloneness and unify the divine name kindle the fire on the altar of their hearts. By their pure thought, all the sefirot are unified and linked to one another until they are drawn to the source of the infinitely sublime flame. Here lies the secret of the unification that a person performs in the morning and evening prayers, raising all the sefirot and unifying them into a single cluster. Thereby one cleaves to the divine name.

REMEMBER GOD and God's love constantly. Let your thought not be separated from God. I declare, both to individuals and to the masses: If you want to know the secret of binding your soul above and joining your thought to God—so that by means of such continuous contemplation you attain incessantly the world that is coming, and so that God be with you always, in this life and the next—then place in front of the eyes of your mind the letters of God's name, as if they were written in a book in Hebrew script. Visualize every letter extending to infinity. What I mean is: when you visualize the letters, focus on them with your mind's eye as you contemplate infinity. Both together: gazing and meditating.

I, RABBI ISAAC of Akko, was contemplating, according to the method I received from the great one of his generation—great in humility, the wisdom of Kabbalah, philosophy, and the science of permutation of letters. He insisted that I set the ten sefirot in front of me, as it is written: "I set YHVH before me always." I saw them today above my head like a pillar, with their feet on my head and their heads high above, beyond all the four worlds: emanation, creation, formation, and actualization. As long as I was contemplating this ladder—the name of the Blessed Holy One—I saw my soul cleaving to Ein Sof.

To ATTAIN you must be alone, so that your contemplation not be disturbed. In your mind, cultivate aloneness to the utmost. Strip your body from your soul, as if you do not feel that you are clothed in matter at all—you are entirely soul. The more you strip yourself of material being, the more powerful your comprehension. If you sense any sound or movement that breaks your meditation, or if any material imagining arises within you, then your soul's contemplation will be severed from the upper worlds. You will attain nothing, since supernal holiness does not abide with anyone attached by even a hair to the material realm. Therefore prophecy or the holy spirit is called deep sleep, dream, or vision. To sum up, even if you are worthy for the holy spirit to rest upon you, if you do not train yourself to completely strip your soul from your body, the spirit will not rest upon you. This is the secret reason that a band of prophets has timbrels, flutes, and other instruments, for through the sweetness of melody, aloneness descends upon them and they strip their souls. Then the musicians stop the melody, and the prophets remain in that supernal state of union and they prophesy.

If you wish to attain aloneness, you must first return to God from having strayed and missed the mark. Be careful not to miss again. Train yourself to eliminate negative habits such as anger, depression, impatience, and chatter.

If you wish to attain aloneness and to receive the holy spirit, regard every insight you gain and every light you perceive as darkness. When you see that you have attained a little, concentrate more deeply in your meditation, until you experience a pure spirit speaking within you words of Torah, wisdom, devotion, purity, and holiness—on its own, without your will. Having attained this, impel yourself to draw forth

the holy spirit often, until you weaken and verge on fainting. Then strengthen yourself and pray this prayer with perfect intention:

"Master of all the worlds! To you it is revealed and known that I am not engaged in all of this for my own glory, but rather for the glory of your name, for the glory of the oneness of your being, so that I will know you, how to serve you and bless your name. Enable me to search for you, discover you. Strengthen me, embolden me. Enlighten my eyes lest I sleep the sleep of death. Create a pure heart for me, O God; rejuvenate within me a steadfast spirit."

Draw forth the spirit until you see and know for certain that it is bound to you perpetually, inseparably, engraved within you.

Sanctify your limbs and adorn them with good deeds, making yourself into a throne for the divine presence, your body an ark for Shekhinah. When you do a good deed, you sanctify yourself.

THE GREATER you are, the more you need to search for your self. Your deep soul hides itself from consciousness. So you need to increase aloneness, elevation of thinking, penetration of thought, liberation of mind—until finally your soul reveals itself to you, spangling a few sparkles of her lights.

Then you find bliss, transcending all humiliations or anything that happens, by attaining equanimity, by becoming one with everything that happens, by reducing yourself so extremely that you nullify your individual, imaginary form, that you nullify existence in the depth of your self. "What are we?" Then you know every spark of truth, every bolt of integrity flashing anywhere.

Then you gather everything, without hatred, jealousy, or rivalry. The light of peace and a fierce boldness manifest in you. The splendor of compassion and the glory of love shine through you. The desire to act and work, the passion to create and to restore yourself, the yearning for silence and for the inner shout of joy—these all band together in your spirit, and you become holy.

WHEN YOU train yourself to hear the voice of God in everything, you attain the quintessence of the human spirit. Usually the mind conceals the divine thoroughly by imagining that there is a separate mental power that constructs the mental images. But by training yourself to hear the voice of God in everything, the voice reveals itself to your mind as well. Then right in the mind, you discover revelation.

"As I was among the exiles on the River Kevar, the heavens opened and I saw visions of God."

As Ezekiel was gazing at the river, Holiness opened the seven heavens for him, and he saw the Power.

A parable has been told. To what can this be compared? To someone who went to the barber. The barber cut his hair and handed him a mirror. As he was looking in the mirror, the king was passing by. He saw the king and his entourage in the mirror as they passed the doorway. The barber exclaimed, "Turn around! See the king!" He replied, "I've already seen him in the mirror."

So, Ezekiel was standing on the River Kevar. As he was gazing at the water, the seven heavens were opened for him and he saw the Glory of Holiness, along with celestial creatures, ministering angels, bands of angels, seraphs, and angels with sparkling wings, all joined to the heavenly chariot. As they were passing through heaven, Ezekiel saw them reflected in the water. As it is written, "on the River Kevar," the River of Already.

God said to Abram, "Go forth."

God said to Abram, "Go to your self, know your self, fulfill your self."

THIS VERSE is addressed to every person. Search and discover the root of your soul, so that you can fulfill it and restore it to its source, its essence. The more you fulfill yourself, the closer you approach your authentic self.

GOD LAVISHES according to the divine force. The one receiving, however, is bounded. If so, the good would be limited. So God lavishes the good immeasurably, according to the divine gauge. Thus the good is divine, limitless, although the created receiver cannot receive it—unless he is completely shattered, and then repaired through his desire to return to the limitless source, to become one with divinity. Thereby the creature realizes himself, attaining the perfection of the Creator, transcending the boundary of the created. This would be impossible—were it not for overflowing goodness, beyond one's capacity to receive.

Dangers of
Contemplation

WHEN YOU are praying, imagine God speaking with you, teaching and conducting you. You receive his words in awe, trembling, and sweat. Contemplate that everything God teaches humanity is infinite, yet thought expands and ascends to her origin. Upon reaching there, she is stopped and can ascend no further.

By way of parable: a spring of water emerging from its source. If you dig beneath it, to prevent the water spreading out in all directions, the water will rise to the level of the source and no further. Similarly, thought can ascend no higher than her origin.

If you dare to contemplate that to which thought cannot expand and ascend, you will not escape one of two consequences. From forcing thought to grasp that which cannot be comprehended, your soul will ascend, be severed, and return to her root, or else your mind will become confused.

WHEN OUR master Moses, peace unto him, said to God, "Show me your Presence," he sought death so that his soul would obliterate the barrier of her palace, which separated her from the wondrous divine light she had aroused herself to see. But since the people of Israel still needed Moses, God did not want Moses' soul to leave her palace to attain this light of his.

Now you, my child, strive to see supernal light, for I have brought you into a vast ocean. Be careful! Keep your soul from gazing and your mind from conceiving, lest you drown. Strive to see, yet escape drowning. Your soul will see the divine light—actually cleave to it—while dwelling in her palace.

Revelation
and Torah

THERE WAS a man who lived in the mountains. He knew nothing about those who lived in the city. He sowed wheat and ate the kernels raw.

One day he entered the city. They brought him good bread. He said, "What is this for?" They said, "Bread, to eat!" He ate, and it tasted very good. He said, "What is it made of?" They said, "Wheat."

Later they brought him cakes kneaded in oil. He tasted them and said, "What are these made of?" They said, "Wheat."

Finally they brought him royal pastry made with honey and oil. He said, "And what are these made of?" They said, "Wheat." He said, "I am the master of all of these, for I eat the essence of all of these: wheat!"

Because of that view, he knew nothing of the delights of the world; they were lost to him. So it is with one who grasps the principle and does not know all those delectable delights deriving, diverging, from that principle.

HOW TO LOOK AT TORAH

RABBI SHIM'ON said,
"Woe to the human being who says
that Torah presents mere stories and ordinary words!
If so, we could compose a Torah right now with ordinary
 words,
and better than all of them.
To present matters of the world?
Even rulers of the world possess words more sublime.
If so, let us follow them and make a Torah out of them.
Ah, but all the words of Torah are sublime words, sublime
 secrets!

"Come and see:
The world above and the world below are perfectly balanced:
Israel below, the angels above.
Of the angels it is written: 'He makes his angels spirits.'
But when they descend, they put on the garment of this
 world.
If they did not put on a garment befitting this world,
they could not endure in this world
and the world could not endure them.

If this is so with the angels, how much more so with Torah,
who created them and all the worlds,
and for whose sake they all exist.
In descending to this world,
if she did not put on the garments of this world,
the world could not endure.

"So this story of Torah is the garment of Torah.
Whoever thinks that the garment is the real Torah

and not something else—may his spirit deflate!
He will have no portion in the world that is coming.
That is why David said:
'Open my eyes, so I can see wonders out of your Torah,'
what is under the garment of Torah.

"Come and see: There is a garment visible to all.
When those fools see someone in a good-looking garment
they look no further.
But the essence of the garment is the body;
the essence of the body is the soul.

"So it is with Torah.
She has a body: the commandments of Torah,
called 'the embodiment of Torah.'
This body is clothed in garments: the stories of this world.
Fools of the world look only at that garment, the story of
 Torah;
they know nothing more.
They do not look at what is under that garment.
Those who know more do not look at the garment,
but rather at the body under that garment.
The wise ones, servants of the King on high,
those who stood at Mount Sinai,
look only at the soul, root of all, real Torah.
In the time to come, they are destined to look at the soul of
 the soul of Torah.

"Come and see: So it is above.
There is garment, body, soul, and soul of soul.
The heavens and their host are the garment.
The Communion of Israel is the body,
who receives the soul, Beauty of Israel.
So she is the body of the soul.

The soul we have mentioned is Beauty of Israel, real Torah.
The soul of the soul is the Holy Ancient One.
All is connected, this one to that one.

"Woe to the wicked who say that Torah is merely a story!
They look at this garment and no further.
Happy are the righteous who look at Torah properly!
As wine must sit in a jar, so Torah must sit in this garment.
So look only at what is under the garment.
All those words and all those stories are garments."

THE OLD MAN AND THE RAVISHING MAIDEN

RABBI HIYYA and Rabbi Yose met one night at the Tower of
Tyre.
They stayed there as guests, delighting in each other.
Rabbi Yose said, "I am so glad to see the face of Shekhinah!
For just now, the whole way here, I was pestered by an old
man,
a donkey driver, who kept asking me riddles the whole way:

" 'Who is a serpent that flies in the air and wanders alone,
while an ant lies peacefully between its teeth?
Beginning in union, it ends in separation.

" 'Who is an eagle that nests in a tree that never was?
Its young who have been plundered,
who are not created creatures,
lie somewhere uncreated.
Going up, they come down; coming down, they go up.
Two who are one, and one who is three.

" 'Who is a ravishing maiden without eyes,
her body concealed and revealed?
She comes out in the morning and is hidden all day.
She adorns herself with adornments that are not.'

"All this he asked on the way; I was annoyed.
Now I can relax.
If we had been together, we would have engaged in words of
Torah
instead of strange words of chaos."

Rabbi Hiyya said, "That old man, the donkey driver,
do you know anything about him?"

Rabbi Yose answered, "I know that there is nothing in his
words.
If he knew anything, he should have opened with Torah;
then the way would not have been empty!"

Rabbi Hiyya said, "That donkey driver, is he here?
For sometimes in those empty fools, you discover bells of
gold!"

Rabbi Yose said, "Here he is, fixing some food for his
donkey."

They called him, and he came over.
He said to them, "Now two are three, and three are like
one!"

Rabbi Yose said, "Didn't I tell you that all his words are
empty nonsense?"

He sat before them and said,
"Rabbis, I turned into a donkey driver only a short
time ago.
Before, I wasn't one.
But I have a small son, and I put him in school;
I want him to engage Torah.
When I find one of the rabbis traveling on the road,
I guide his donkey from behind.
Today I thought that I would hear new words of Torah,
but I haven't heard anything!"

Rabbi Yose said, "Of all the words I heard you say,
there was one that really amazed me.
Either you said it out of folly, or they are empty words."

The old man said, "And which one is that?"

He said, "The one about the ravishing maiden."

The old man opened and said,
" 'YHVH is on my side; I have no fear.
What can any human do to me?
YHVH is by my side, helping me.
It is good to take refuge in YHVH.'

"How good, pleasant, precious, and high are words of Torah!
But how can I say them in front of rabbis
from whose mouths, until now, I haven't heard a single
 word?
But I should say them
because there is no shame at all in saying words of Torah
in front of everyone!"

The old man covered himself.
The old man opened and said,
" 'Moses went inside the cloud and ascended the mountain.'
What is this cloud?
The same one of which it is written:
'I have placed my bow in the cloud.'
We have learned that the rainbow took off her garments
and gave them to Moses.
Wearing that garment, he went up the mountain;
from inside it he saw what he saw,
delighting in the all, up to that place."

The companions approached
and threw themselves down in front of the old man.
They cried, and said, "If we have come into the world
only to hear these words from your mouth,
it is enough for us!"

The old man said,
"Companions, not for this alone did I begin the word.
An old man like me doesn't rattle with just a single word.
Human beings are so confused in their minds.
They do not see the way of truth in Torah.
She calls out to them every day, in love,
but they do not want to turn their heads.
She removes a word from her sheath,
is seen for a moment, then quickly hides away,
but she does so only for those who know her intimately.

"A parable.
To what can this be compared?
To a beloved, ravishing maiden, hidden deep within her
 palace.
She has one lover, unknown to anyone, hidden too.
Out of love for her, this lover passes by her gate constantly,
lifting his eyes to every side.
Knowing that her lover hovers about her gate constantly,
what does she do?
She opens a little window in her hidden palace,
revealing her face to her lover,
then swiftly withdraws, concealing herself.
No one near him sees or reflects, only the lover,
and his heart and his soul and everything within him
flow out to her.
He knows that out of love for him
she revealed herself for that one moment
to awaken love in him.

"So it is with a word of Torah:
she reveals herself to no one but her lover.
Torah knows that one who is wise of heart

hovers about her gate every day.
What does she do?
She reveals her face to him from the palace
and beckons him with a hint,
then swiftly withdraws to her hiding place.
No one there knows or reflects—
he alone does,
and his heart and his soul and everything within him
flows out to her.
This is why Torah reveals and conceals herself.
With love she approaches her lover
to arouse love with him.

"Come and see the way of Torah.
At first, when she begins to reveal herself to a human,
she beckons him with a hint.
If he perceives, good;
if not, she sends him a message, calling him simple.
Torah says to her messenger:
'Tell that simple one to come closer, so I can talk with him.'
He approaches.
She begins to speak with him from behind a curtain she has
 drawn,
words he can follow, until he reflects a little at a time.
This is *derasha*.
Then she converses with him through a veil,
words riddled with allegory.
This is *haggadah*.

"Once he has grown accustomed to her,
she reveals herself face to face
and tells him all her hidden secrets,
all the hidden ways,
since primordial days secreted in her heart.

"Now he is a complete human being,
husband of Torah, master of the house.
All her secrets she has revealed to him,
withholding nothing, concealing nothing.

"She says to him, 'Do you see that word,
that hint with which I beckoned you at first?
So many secrets there! This one and that one!'

"Now he sees that nothing should be added to those words
and nothing taken away.
Now the *peshat* of the verse, just like it is.
Not even a single letter should be added or deleted.

"Human beings should become aware,
pursuing Torah to become her lovers."

The old man was silent for a moment.
The companions were amazed;
they did not know if it was day or night,
if they were really there or not.

"Enough, companions!
From now on, you know that evil has no power over you.
I, Yeiva Sava, have stood before you
to awaken your awareness of these words."

They rose as if awakened from sleep
and threw themselves down in front of him,
unable to utter a word.
After a while they began to cry.
Rabbi Hiyya opened and said,
" 'Set me as a seal upon your heart,
as a seal upon your arm.'

Love and sparks from the flame of our heart will escort you.
May it be the Will
that our image be engraved in your heart
as your image is engraved in ours."

He kissed them and blessed them, and they left.

When they rejoined Rabbi Shim'on
and told him everything that happened,
he was delighted and amazed.
He said, "You are fortunate to have attained all this.
Here you were with a heavenly lion,
a fierce warrior for whom many warriors are nothing,
and you could not recognize him!
I am amazed that you escaped his punishment.
The Blessed Holy One must have wanted to save you."

He called out these verses for them:
"The path of the righteous is like the light of dawn,
growing brighter and brighter until the day is full.
When you walk, your stride will be free;
if you run, you will not stumble.
Your people, all of them righteous, will inherit the land
 forever—
a sprout of my planting, the work of my hands, making me
 glorious."

LET US awaken to the mystery of Torah, musing on her day and night. The written Torah and the oral Torah are joined together like an almond bud and its blossom—neither one concealed from the other, growing on a single stalk, like male and female joined in love. Both emerge from the sheer, inner voice, to exist as one. From there the written Torah draws, and the oral Torah suckles from the written. Clasping one another, they are inseparable. One is general, the other specific. You cannot have one without the other.

However, the written Torah is an unripe fruit of supernal wisdom. Wisdom is the root: the all-inclusive, noetic point, from which all paths diverge. Both the written and oral Torah arise in Binah, the sheer voice that ordains and sustains everything. From there they emerge into being through the power of wisdom, hidden and concealed. Therefore the sages have said, "Torah is an unripe fruit of supernal wisdom."

But isn't the Torah the source of life? How can you say that she is unripe? What is unripe is inferior! Like fruit that falls prematurely from a tree and ripens on the ground: it isn't as good as fruit that ripens on the branch.

Look! The root of Torah is supernal wisdom—hidden and concealed, perceived only through its wondrous pathways. How wondrous are the offshoots! But since the root is wisdom, who can ever reach it? That is why Israel's sweet singer sang, "Open my eyes, so I can see wonders out of your Torah!"

THE SCROLL of the Torah is written without vowels, so you can read it variously. Without vowels, the consonants bear many meanings and splinter into sparks. That is why the Torah scroll must not be vocalized, for the meaning of each word accords with its vowels. Once vocalized, a word means just one thing. Without vowels, you can understand it in countless, wondrous ways.

Living
in the
Material
World

THE PURPOSE of the soul entering this body is to display her powers and actions in this world, for she needs an instrument. By descending to this world, she increases the flow of her power to guide the human being through the world. Thereby she perfects herself above and below, attaining a higher state by being fulfilled in all dimensions. If she is not fulfilled both above and below, she is not complete.

Before descending to this world, the soul is emanated from the mystery of the highest level. While in this world, she is completed and fulfilled by this lower world. Departing this world, she is filled with the fullness of all the worlds, the world above and the world below.

At first, before descending to this world, the soul is imperfect; she is lacking something. By descending to this world, she is perfected in every dimension.

You CAN mend the cosmos by anything you do—even eating. Do not imagine that God wants you to eat for mere pleasure or to fill your belly. No, the purpose is mending.

Sparks of holiness intermingle with everything in the world, even inanimate objects. By saying a blessing before you enjoy something, your soul partakes spiritually. This is food for the soul. As the Torah states: "One does not live on bread alone, but rather on all that issues from the mouth of God." Not just the physical, but the spiritual—the holy sparks, springing from the mouth of God. Like the soul herself, breathed into us by God.

So when you are about to eat bread, say the *motsi:* "Blessed are you, YHVH our God, sovereign of the world, who brings forth bread from the earth." Then by eating, you bring forth sparks that cleave to your soul.

WHEN YOU eat and drink, you experience enjoyment and pleasure from the food and drink. Arouse yourself every moment to ask in wonder, "What is this enjoyment and pleasure? What is it that I am tasting?"

Answer yourself, "This is nothing but the holy sparks from the sublime, holy worlds that are within the food and drink."

THE GREATEST PATH

WHEN YOU desire to eat or drink, or to fulfill other worldly desires, and you focus your awareness on the love of God, then you elevate that physical desire to spiritual desire. Thereby you draw out the holy spark that dwells within. You bring forth holy sparks from the material world. There is no path greater than this. For wherever you go and whatever you do—even mundane activities—you serve God.

WE CONSTANTLY aspire to raise the holy sparks. We know that the potent energy of the divine ideal—the splendor at the root of existence—has not yet been revealed and actualized in the world around us. Yet the entire momentum of being approaches that ideal.

The ideal ripens within our spirit as we ascend. As we become aware of the ideal, absorbing it from the abundance beyond bounded existence, we revive and restore all the fragments that we gather from life—from every motion, every force, every dealing, every sensation, every substance, trivial or vital. The scattered light stammers in the entirety, mouthing solitary syllables that combine into a dynamic song of creation. Sprinkling, then flowing, this light of life is suffused with holy energy.

We raise these scattered sparks and arrange them into worlds, constructed within us, in our private and social lives. In proportion to the sparks we raise, our lives are enriched. Everything accords with how we act. The higher the aspiration, the greater the action; the deeper the insight, the higher the aspiration.

EVERYTHING ASPIRES

WE CANNOT identify the abundant vitality within all living beings, from the smallest to the largest, nor the hidden vitality enfolded within inanimate creation. Everything constantly flows, vibrates, and aspires. Nor can we estimate our own inner abundance. Our inner world is sealed and concealed, linked to a hidden something, a world that is not our world, not yet perceived or probed.

Everything teems with richness, everything aspires to ascend and be purified. Everything sings, celebrates, serves, develops, evolves, uplifts, aspires to be arranged in oneness.

•

SECULAR AND HOLY

THERE IS a secular world and a holy world, secular worlds and holy worlds. These worlds contradict one another. The contradiction, of course, is subjective. In our limited perception we cannot reconcile the sacred and the secular, we cannot harmonize their contradictions. Yet at the pinnacle of the universe they are reconciled, at the site of the holy of holies.

THERE IS one who sings the song of his soul, discovering in his soul everything—utter spiritual fulfillment.

There is one who sings the song of his people. Emerging from the private circle of his soul—not expansive enough, not yet tranquil—he strives for fierce heights, clinging to the entire community of Israel in tender love. Together with her, he sings her song, feels her anguish, delights in her hopes. He conceives profound insights into her past and her future, deftly probing the inwardness of her spirit with the wisdom of love.

Then there is one whose soul expands until it extends beyond the border of Israel, singing the song of humanity. In the glory of the entire human race, in the glory of the human form, his spirit spreads, aspiring to the goal of humankind, envisioning its consummation. From this spring of life, he draws all his deepest reflections, his searching, striving, and vision.

Then there is one who expands even further until he unites with all of existence, with all creatures, with all worlds, singing a song with them all.

There is one who ascends with all these songs in unison— the song of the soul, the song of the nation, the song of humanity, the song of the cosmos—resounding together, blending in harmony, circulating the sap of life, the sound of holy joy.

SEXUAL UNION is holy and pure, when performed in the right way, at the right time, and with the right intention. Let no one think that there is anything shameful or ugly in such union. God forbid! The right kind of union is called *knowing*. It isn't called that for nothing. Unless it were very holy, it would not be called *knowing*.

This matter is not as Rabbi Moses Maimonides, of blessed memory, imagined and thought in his *Guide of the Perplexed*, where he praises Aristotle for stating that the sense of touch is shameful. God forbid! This matter is not as that Greek said; what he said smacks of subtle heresy. If that Greek scoundrel believed that the world was created with divine intention, he would not have said what he said. But we, who possess the holy Torah, believe that God created everything as divine wisdom decreed. God created nothing shameful or ugly. If sexual union is shameful, then the genitals are too. Yet God created them! How could God create something blemished, disgraceful, or deficient? After all, the Torah states: "God saw everything that he had made, and behold: very good!"

The evidence is clear. In the account of Creation we read: "The two of them were naked, the man and his wife, yet they felt no shame." Before they ate from the Tree of Knowledge, they were contemplating the pure forms, and their intention was entirely holy. To them, the genitals were like eyes or hands or other parts of the body.

When sexual union is for the sake of heaven, there is nothing as holy or pure. The union of man and woman, when it is right, is the secret of civilization. Thereby, one becomes a partner with God in the act of Creation. This is the secret meaning of the saying of the sages: "When a man unites with his wife in holiness, the divine presence is between them."

Human thought has the power to expand and ascend to its origin. Attaining the source, she is joined with the upper light from which she emanated. She and he become one. Then, when thought emanates once again, all becomes a single ray: the upper light is drawn down by the power of thought. In this way the divine presence appears on earth. A bright light shines and spreads around the place where the meditator is sitting. Similarly, when a man and a woman unite, and their thought joins the beyond, that thought draws down the upper light.

You should welcome her with words that draw her heart, calm her mind, and bring her joy. Then her mind will be linked with yours, and your intention with hers. Speak with her in words that arouse desire, love, and passionate union— and in words that draw her to the awe of God.

I ONCE heard a chaste man bemoaning the fact that sexual union is inherently pleasurable. He preferred that there be no physical pleasure at all, so that he could unite with his wife solely to fulfill the command of his Creator: "Be fruitful and multiply."

What he said helped me understand a saying of our rabbis, may their memory be a blessing: "One should hallow oneself during sexual union." I took this to mean that one should sanctify one's thought by eliminating any intention of feeling physical pleasure. One should bemoan the fact that pleasurable sensation is inherent to this act. If only it were not so!

Sometime later, God favored me with a gift of grace, granting me understanding of the essence of sexual holiness. The holiness derives precisely from feeling the pleasure. This secret is wondrous, deep, and awesome.

HOLINESS IS twofold. It begins as service to God, but it ends as a benefit. At first it is effort, then a gift. In other words, if you strive to be holy, you are eventually endowed with holiness. The effort consists in separating and removing yourself from the material aspect of things and linking yourself with the divine. Even when dealing with your body and its needs, your soul should not stir from her union.

But it is impossible to attain this state on your own. After all, you are physical—flesh and blood. So ultimately, holiness is a gift. What you *can* do is strive to pursue true knowledge. Be persistent in learning how to sanctify what you do. In the end, the Blessed Holy One will guide you on the path that it wishes and impart holiness to you, so that you become holy. Then you will succeed, attaining union continuously. Even your bodily actions are transformed into holy deeds. You are walking in the presence of God while being right here in this world. You become a dwelling place of the divine.

The
Wisdom
of
Kabbalah

WHAT SHOULD your intention be as you draw near to this wisdom?

Pursuing the straight path, dividing your time between Bible, Talmud, and this wisdom, partaking of each. Learning this wisdom for its own sake: to enter its mysteries, to know your Creator, to attain a wondrous level of comprehension of the Torah, to pray in the presence of your Creator, to unite the Blessed Holy One and Shekhinah by enacting the mitsvot. This is the worship pleasing to God. Then you will walk the path safely. When you lie down, you will not fear. Faithfully God will make you aware of aspects of the divine Torah that no one else has yet attained. For each soul has a unique portion in the Torah.

Try to learn from someone who has followed paths of integrity, as far as possible, for the treasures of God have been entrusted in that person's hands. Do not chase after those who boast of their knowledge. Their voices roar like the waves of the sea, but they have only a few spoonfuls of wisdom. Many times I have experienced this myself.

This has also befallen some authors, who compose books with riddles, rhyme, and flowery language; their words are encumbered by excess. We need not go into this; it is improper to cast aspersions on that which is holy. The books to which you should cleave, in order to improve, are the compositions of Rabbi Shim'on bar Yohai, namely, the various parts of the *Zohar*. Of the books of his predecessors: *Sefer Yetsirah* and *Sefer ha-Bahir*. Of more recent works: *The Fountain of Wisdom, Chapters of the Chariot, Chapters of Creation*, and similar writings. Cleave to these in love; you will then succeed in this wisdom, provided you delve deeply and reflect intensely. Then you will discover most of what is found in the more recent commentaries, which you will no longer need. It

is not our intention, God forbid, to declare these latter writings unfit, but rather to designate for the seeker the path that is short, although it is long.

Peruse these books in two ways. First, go over the language of the text many times, taking notes to remember fluently. Do not delve deeply at first. Second, study with great concentration, according to your ability. Even if it seems that you do not understand, do not stop, because God will faithfully help you discover hidden wisdom. As a parent trains a child, so does God purify one engaged in this wisdom, little by little. I have experienced this innumerable times.

If something in this wisdom seems doubtful to you, wait. As time passes, it will be revealed to you. The essential reward of this wisdom is derived from waiting for the secrets that will be revealed to you in the course of time. This is demonstrated in several passages in the *Zohar;* often something that had been doubtful to them for a long time would suddenly be seen anew. They had a saying for this: "I have been pursuing this word all the days of my life!"

Those who persevere in this wisdom find that when they ponder these teachings many times, knowledge grows within them—an increase of essence. The search always leads to something new.

SOMETHING YOU cannot explain to another person is called *nistar*, "hidden," like the taste of food, which is impossible to describe to one who has never tasted it. You cannot express in words exactly what it is—it is hidden. Similarly with the love and awe of God: It is impossible to explain to another what the love in your heart feels like. This is hidden.

But calling the wisdom of Kabbalah "hidden" is strange. How is it hidden? Whoever wants to learn—the book is readily available. If one does not understand, he is ignorant. For such a person, the Talmud is also hidden! Rather, the secrets hidden throughout the *Zohar* and the writings of the *Ari* are based entirely on cleaving to God—for one worthy to cleave.

WHOEVER DELVES into mysticism cannot help but stumble, as it is written: "This stumbling block is in your hand." You cannot grasp these things unless you stumble over them.

Notes

Abraham Abulafia (thirteenth century), *Mafteah ha-Tokhahot;* see
Moshe Idel, *The Mystical Experience in Abraham Abulafia* (Albany:
State University of New York Press, 1988), 188; and Idel, *The Mystical Experience in Abraham Abulafia,* Hebrew edition (Jerusalem:
Magnes Press, 1988), 140.

to maintain . . . the joy of apprehension Hebrew, *qiyyum hatmadat
ha-messig im ta'anug hassagato.*

THE NATURE OF GOD

Moses Cordovero (sixteenth century), *Or Ne'erav,* ed. Yehuda Z.
Brandwein (Jerusalem: Yeshivat Qol Yehudah, 1965), 2:2 (18b–19a).
See Ira Robinson, *Moses Cordovero's Introduction to Kabbalah: An
Annotated Translation of His Or Ne'erav* (New York: Yeshiva University Press, 1994), 51–52.

"The Ancient-of-Days sits . . . " Daniel 7:9.

corporealizes God Cf. Maimonides, *Mishneh Torah,* "Fundamentals
of Torah," 1:9; Maimonides, *Guide of the Perplexed* 1:26: "The multitude cannot at first conceive of any existence save that of body
alone; thus that which is neither a body nor existent in a body does
not exist in their opinion."

EIN SOF: GOD AS INFINITY

NONDUALITY

First passage: Moses Cordovero (sixteenth century), *Shi'ur Qomah,*
Modena Manuscript, 206b, commenting on Zohar 3:141b (*Idra*

Rabba); see Bracha Sack, in *Tarbits* 58 (1989): 213. Second passage: Moses Cordovero, *Elimah Rabbati* (Jerusalem: Ahuzat Yisra'el, 1966), 24d–25a.

Ein Sof The Infinite.

GOD'S ENCAMPMENT

El'azar of Worms (thirteenth century), *Sefer ha-Shem*; see Moshe Idel, *Kabbalah: New Perspectives* (New Haven: Yale University Press, 1988), 144; 346, n. 281.

THE CHAIN OF BEING

Moses de León (thirteenth century), *Sefer ha-Rimmon* (*The Book of the Pomegranate*), ed. Elliot R. Wolfson (Atlanta: Scholars Press, 1988), 181–82. See Scholem, *Major Trends in Jewish Mysticism*, 223.

in heaven and on earth. There is nothing else. Deuteronomy 4:39. The final words—*ein od*—can be translated "there is no other (God)" or "there is nothing else." The first alternative conveys the literal meaning of the biblical verse; the second, its mystical expansion.

EIN SOF AND YOU

Moses Cordovero (sixteenth century), *Shi'ur Qomah* (Warsaw, 1883), 16d–17a.

YOU ENLIVEN EVERYTHING

Moses Cordovero (sixteenth century), *Or Yaqar* (Jerusalem: Ahuzat Yisra'el, 1987), 15:203a.

sefirot The stages of divine emanation, aspects of God's personality; see the introduction.

"You enliven everything" Nehemiah 9:6, referring to everything in heaven and earth, and usually translated: "You keep them all alive."

"God's presence fills the entire world" Isaiah 6:3.

EIN SOF

Azriel of Gerona (thirteenth century), "Commentary on the Ten Se-*firot*," in Me'ir ibn Gabbai, *Derekh Emunah* (Warsaw, 1850), 2b–c,

3a–d; cf. Joseph Dan and Ronald C. Kiener, *The Early Kabbalah* (Mahwah, NJ: Paulist Press, 1986), 89–91, 93–94.

absolute undifferentiation . . . At the deepest levels of divinity, all opposites and distinctions vanish, overwhelmed by oneness. Here Azriel of Gerona describes this undifferentiated state in language influenced by John Scotus or other Neoplatonists who speak of *indistinctio* and *indifferentia*. Scotus had written (*Periphyseon* 517b–c) that God "is the circuit of all things that have or do not have being and that seem contrary or opposite to him. He gathers and composes them all with an ineffably beautiful harmony into a single concord." Cf. Azriel, *Commentary on Sefer Yetsirah* (printed under the name of Nahmanides) 1:7: Ein Sof "is undifferentiated by anything, and everything unites in its undifferentiation, for all is undifferentiated in it."

the root of rebellion To believe only in Ein Sof, the absolute divinity, and not in the personal God embodied in the ten sefirot, is an act of rebellion against tradition.

"One who is righteous lives by his faith" Habakkuk 2:4.

by way of no By negation. Negative theology attempts to strip God of all attributes, thereby coming closer and closer to the undefinable divine essence. The kabbalists outdo the philosophers by speaking of divine nothingness; see the introduction, and "*Ayin:* Mystical Nothingness," pp. 65–72. Since the ultimate nature of God cannot be comprehended, one kabbalist, David ben Judah he-Hasid (in his *Book of Mirrors: Sefer Mar'ot ha-Tsove'ot*, ed. Daniel C. Matt [Chico, CA: Scholars Press, 1982], 261), actually calls God *Lo*, *No*.

the ten sefirot The stages of divine emanation, aspects of God's personality; see the introduction.

that can be quantified The term sefirot is derived from the root SFR, "to count." Originally, in *Sefer Yetsirah*, the sefirot were understood as "numerical entities." Azriel sees them as the animating principle of all things that exist, that can be quantified.

through differentiation The sefirot manifest the infinite energy of Ein Sof. It is unclear, perhaps intentionally, where the metaphor of the candles stops and the description of the relation between Ein Sof and the sefirot begins.

"I am that I am" The divine name revealed by God to Moses in Exodus 3:14.

Abraham Isaac Kook (twentieth century), *Orot ha-Qodesh* (Jerusalem: Mossad ha-Rav Kook, 1963–64), 1:269.

EVOLUTION AND KABBALAH

Abraham Isaac Kook (twentieth century), *Orot ha-Qodesh*, 2:537.

Ein Sof generates, actualizes potential infinity As opposed to Darwinian theory, which insists that evolution is a purposeless and unguided process, Kook maintains that evolution is profoundly purposeful—an expression of the divine will. Through evolution, Ein Sof is actualized.

HERETICAL FAITH

Abraham Isaac Kook (twentieth century), "Pangs of Cleansing," in *Orot* (Jerusalem: Mossad ha-Rav Kook, 1961), 124–28; see Kook, *Abraham Isaac Kook: The Lights of Penitence, The Moral Principles, Lights of Holiness, Essays, Letters, and Poems*, tr. Ben Zion Bokser (Mahwah, NJ: Paulist Press, 1978), 261–67.

much thinking about the essence of God For Rav Kook, the essence of God cannot be defined; thinking about it is counterproductive.

the heresy that paves the way for the Messiah Cf. Mishnah, *Sotah* 9:15: "As the Messiah approaches, insolence [*hutspa*] will increase."

EIN SOF AND THE SEFIROT

WATER, LIGHT, AND COLORS

Moses Cordovero (sixteenth century), *Pardes Rimmonim* (Jerusalem: Mordekhai Etyah, 1962), 4:4, 17d–18a.

Ein Sof emanated ten sefirot See the introduction.

the external sefirot Cordovero distinguishes between the essence of the sefirot and the external aspect of the sefirot, which channels this essence.

Hesed, Gevurah, and Tif'eret . . . white, red, and green, respectively Hesed, free-flowing divine love, is pure white; Gevurah, power, also

known as *Din* (harsh judgment), is red; Tif'eret, beauty, is green, the color of harmony.

neither judgment nor compassion, neither right nor left The opposite poles of the sefirot: judgment on the left, compassion on the right.

EIN SOF AND THE SEFIROT

Moses Cordovero (sixteenth century), *Or Ne'erav,* ed. Yehuda Z. Brandwein, 6:1 (42a–b, 43a–45a); 6:2 (45a–46b); 6:3 (47a–48b); 6:4 (49a–51b); 6:5 (51b–53b); 6:6 (55a–b). See Robinson, *Moses Cordovero's Introduction to Kabbalah,* 111–46 passim.

necessary being Unlike all other existing things, whose existence is merely contingent.

the world of separation and below The worlds outside and below the ten sefirot. These lower worlds are characterized by multiplicity and fragmentation.

unerasable names According to rabbinic tradition (Babylonian Talmud, *Shevu'ot* 35a), certain divine names, once written, may not be erased because of their intrinsic holiness. The talmudic list is nearly identical with the names listed here by Cordovero.

Keter **. . . Adonai** Cordovero identifies a particular biblical divine name for each of the ten sefirot (except the sefirah of *Hod,* which is usually paired with Netsah). On the sefirot, see the introduction. As for the divine names listed here, Eheyeh means "I am" (as in "I am that I am"); Yah is an abbreviated form of YHVH; Elohim and El are both usually rendered as "God"; Tseva'ot means "hosts" (as in "Lord of Hosts"); Shaddai, usually translated "Eternal," may mean "powerful"; El Hai means "living God"; Adonai means "my Lord."

Da'at "Knowledge," or awareness. Da'at, harmonizing Hokhmah and Binah, is not considered a separate sefirah but rather the external aspect of Keter; see Gershom Scholem, *Kabbalah* (Jerusalem: Keter, 1974), 107.

ten sefirot called by name . . . The ten sefirot from Keter to Malkhut. These serve as vessels or garments for their souls or essences, the subtle emanation of ten primal sefirot.

creation . . . formation . . . actualization These three worlds emanate from the world of the sefirot (also known as the world of emanation); see later in this selection, and Scholem, *Kabbalah,* 118–19.

the six dimensions The six sefirot between Binah and Malkhut: Hesed, Gevurah, Tif'eret, Netsah, Hod, and Yesod.

the Divine Mind, Wisdom, and Understanding Hebrew, *sekhel ve-hokhmah u-vinah.* Keter is here referred to as *sekhel,* "intellect" or mind.

the hidden substance that creates all that exists Ein Sof.

"Let the mother go . . . the children you may take" Deuteronomy 22:7. According to the Torah, one who finds a bird's nest must not take the mother along with her fledglings or eggs. In the Kabbalah this verse is understood to refer to the divine mother, Binah, and her seven children, the seven lower sefirot. The mystical seeker is instructed not to contemplate Binah and beyond, but rather to focus on the sefirot from Hesed to Malkhut.

the aliens Hebrew, *ha-hitsonim,* "the outside ones," the demonic forces that torment human beings. They are empowered by human misconduct, and overcome by holiness and love.

the left The side of Gevurah.

on the right The side of Hesed.

"My beloved is white and ruddy." Song of Songs 5:10, understood in Midrash and Kabbalah as a description of the divine lover.

yellow Hebrew, *yaroq,* which usually means "green" but can also mean "yellow." Cordovero may have in mind a gem such as topaz.

but between none of the others While all of the sefirot strive toward union, only these two pairs participate in erotic union.

"His left hand beneath my head, his right arm embracing me" Song of Songs 2:6, understood here as referring to Hesed and Gevurah, the right and left arms of the sefirotic body, which together embrace Malkhut.

Yesod, the mystery of the covenant Yesod represents the phallus in the body of the sefirot, as well as the sign of circumcision, the covenant enacted between God and Abraham.

between Hesed and Din Between grace and strict judgment. Din (Judgment) is another name for the sefirah of Gevurah (Power).

Tif'eret in the mystery of Da'at Da'at is the hidden sefirotic potency mediating between Hokhmah and Binah.

by virtue of being with the emanator, it is black Since Keter is joined with Ein Sof, it partakes of the unknowability of the infinite, symbolized by the color black.

these qualities blend together in Binah The yellow of Tif'eret (see p. 45) and the blue of Hokhmah combine to form the green of Binah.

four divisions Usually referred to as "the four worlds"; see Scholem, *Kabbalah*, 118–19; Aryeh Kaplan, *Sefer Yetzirah: The Book of Creation* (York Beach, ME: Samuel Weiser, 1990), 42, table 7.

unerasable names The divine names that, once written, may not be erased; see pp. 39, 169. Each of these is ascribed to a particular sefirah.

Y symbolizes Hokhmah . . . H, Malkhut Each letter of the name YHVH alludes to a particular sefirah or cluster of sefirot. The *yod* (Y), which looks somewhat like a dot, represents the primordial point, the sefirah of Hokhmah. The *he* (H), which can signify feminine gender, represents the divine mother, Binah. The *vav* (V), which has a numerical value of six, symbolizes the six sefirot between Binah and Malkhut: Hesed, Gevurah, Tif'eret, Netsah, Hod, and Yesod. The final *he* (H) alludes to Malkhut herself. The first sefirah, Keter, is often identified with the tiny crown that adorns the yod of YHVH.

DIVINE QUALITIES

Tiqqunei ha-Zohar (thirteenth–fourteenth centuries), ed. Reuven Margaliot (Jerusalem: Mossad ha-Rav Kook, 1978), introduction, 17a.

Elijah opened Aramaic, *petah eliyahu*. The prophet Elijah is here addressing Rabbi Shim'on bar Yohai in the heavenly academy. This passage appears in the introduction to *Tiqqunei ha-Zohar* (*Embellishments on the Zohar*), composed shortly after the *Zohar* itself, perhaps by a disciple of Moses de León. The passage was introduced into the daily and Sabbath eve liturgy by Isaac Luria in the sixteenth century; it has become known as Petah Eliyahu.

one—but not in counting The oneness of Ein Sof is not the same as the number one, which is simply a member of the series one, two, three. . . .

you conceal yourself By clothing itself in the sefirot, Ein Sof conceals itself, yet this concealment is simultaneously an unfolding

manifestation of Ein Sof, according to the pattern of the sefirot. Without such concealment, the Infinite would be incomprehensible and unbearable.

binds and unites them . . . as if he divided you The energy of Ein Sof animates and unifies the sefirot. One who ascribes separate, independent existence to any individual sefirah denies and defaces the oneness of Ein Sof.

one long, one short, one between The sefirot are classified according to length, like light waves. At the long end of the spectrum—the right column of the sefirot—is Hesed, love; at the short end—the left column—is Din, judgment and rigor. Mediating between these extremes is the harmony of Rahamim, compassion.

garments for them . . . bodies for them The ten sefirot of emanation are clothed in the sefirot of three lower worlds: creation, formation, and actualization. The sefirot of each world constitute a garment for the preceding world, as well as a body that is clothed in the sefirot of the following world.

from which souls fly to human beings Each human soul, born of the union of Tif'eret and Malkhut, passes through the worlds of creation, formation, and actualization, before reaching her destination in the human body, her palace.

this arrangement The sefirot are traditionally arranged according to the structure of the human body.

completion of the body, sign of the holy covenant Yesod is symbolized by the phallus, the site of circumcision, which is the sign of the covenant.

Malkhut, the mouth . . . oral Torah The last sefirah is associated with speech; she is the oral Torah, expanding upon Tif'eret, the written Torah.

heartmind Aramaic, *libba,* corresponding to Hebrew, *lev,* "heart." In Hebrew, the heart is the seat of the intellect as well as the emotions.

the royal crown Hebrew, *keter malkhut,* a name that includes both the first and the last sefirot; cf. *Sefer Yetsirah* 1:7: "Their end is embedded in their beginning, their beginning in their end," and Isaiah 46:10, cited here by the *Tiqqunei ha-Zohar:* "foretelling the end from the beginning."

the skull Surrounding the brain, Hokhmah.

yod he vav he The four letters of YHVH, which allude to all ten sefirot, already preexist within Keter.

sap of the tree From within Keter, "the root of roots," the energy permeates the trunk, arms, and branches of the sefirotic tree.

within or without Ein Sof can be depicted neither by nondivine images nor by the sefirot.

So that the beyond might be known . . . become known By contemplating creation, one can sense the divine pattern and rhythm.

a name that is known Aramaic, *shem yedi'a,* "a known name," or "a certain, specific name." The word *yedi'a,* "known," reappears a number of times in the following lines.

by which the angels are called Certain angels are identified with particular sefirot, for example, Michael with Hesed, Gavriel with Gevurah.

When you disappear from them . . . without a soul Without Ein Sof, the sefirot and everything that can be named would be lifeless.

not with a known wisdom. . . . The wisdom and understanding of Ein Sof are not separate qualities but rather inherent to the nature of Ein Sof. The sefirot Hokhmah (Wisdom) and Binah (Understanding) are given these names because they convey the inherent wisdom and understanding of Ein Sof.

according to human action Human action and behavior affect the sefirot, either positively or negatively. Righteous action unites the sefirot and ensures the flow of emanation, blessing, and compassion to the world; sin ruptures the divine union, interrupts the flow, and empowers the demonic.

nor any quality at all Literally, "nor any of these qualities at all," that is, any of the sefirot, also known as *middot,* "qualities." Ein Sof cannot be confined by any label—even divine labels.

THE CREATION OF GOD

Zohar 1:15a (thirteenth century); see Daniel C. Matt, *Zohar: The Book of Enlightenment,* The Classics of Western Spirituality (Mahwah, NJ: Paulist Press, 1983), 49–50, 207–10.

In the beginning Genesis 1:1. What follows is the *Zohar*'s commentary on the opening words of the Torah.

the King The Infinite, Ein Sof, about to begin its manifestation.

the luster on high The brilliance of the first sefirah, Keter, the Crown. Keter is coeternal with Ein Sof.

a blinding spark Aramaic, *botsina de-qardinuta*. The spark is overwhelming, so bright and powerful that it cannot be seen. This blinding spark is the first impulse of emanation proceeding from Ein Sof through Keter. The goal of meditation is to attain this spark and participate in the primal flow of being. Many mystics convey similar paradoxical images: "a ray of divine darkness" (Dionysius, *Mystical Theology* 1:1); "the luminous darkness" (Gregory of Nyssa, *Life of Moses* 2:163); "the black light" (Iranian Sufism). Prior to the *Zohar*, Azriel of Gerona and the author of *Ma'ayan ha-Hokhmah* mention "the light that is darkened from shining"; see Mark Verman, *The Books of Contemplation: Medieval Jewish Mystical Sources* (Albany: State University of New York Press, 1992), 59, 158–59; and Matt, *Zohar*, 208–9.

the concealed of the concealed The luster on high, the first and most hidden sefirah, Keter.

the Infinite Ein Sof.

a ring Keter, the crown.

not white, not black, not red, not green These four colors are associated with four sefirot: Hesed, Shekhinah, Gevurah, and Tif'eret, none of which appears until a later stage of emanation.

When a band spanned . . . The spark that is a vapor is also a band or cord (Aramaic, *meshiha*), referred to elsewhere in the *Zohar* as *qav ha-middah*, "the line of measure." This line maps out the path and stages of emanation, the spectrum of divine colors.

concealed within the concealed . . . The flow of emanation has just begun; everything is still hidden within the mystery of Ein Sof.

broke through and did not break through its aura The nature of the breakthrough is impossible to describe; so the act is stated and immediately denied. The aura (or "ether" or "air"; Aramaic, *avira*) is Keter; see Gershom Scholem, *Origins of the Kabbalah* (Philadelphia: Jewish Publication Society, 1987), 331–47 (and especially the reference to the breakthrough of the *avir* on 342); Verman, *The Books of Contemplation*, 153–56; and *Sefer Yetsirah* 2:6 ("Letters of Creation," p. 102): "Out of chaos God formed substance, making what is not

into what is. He hewed enormous pillars out of ether that cannot be grasped."

Beginning The flow of emanation manifests as a point of light. This is the second sefirah, Hokhmah, Wisdom. It is the beginning mentioned in the first verse of Genesis. The point is called Beginning because it is the first ray of divine light to appear outside of Keter, the first aspect of God that can be known.

"The enlightened will shine . . . forever and ever" Daniel 12:3.

like the *zohar* of the sky In the biblical verse, *zohar* means "radiance, splendor, brilliance." Here the word also designates the hidden power of emanation (see below) and the title of the book.

Zohar . . . this point The spark of emanation flashes again, and Keter, the aura, transmits the impulse to Hokhmah, the point of Wisdom.

a glorious palace . . . sowed the seed . . . The purpose of emanation is to display the glory of the hidden God. This is achieved through a rhythm of revelation and concealment. The point expands into a circle, a palace—the third sefirah, Binah (Understanding). She is the divine womb; the seed of holiness, another name for Hokhmah, is sown inside her. Binah gives birth to the seven lower sefirot, which engender the rest of creation.

The silkworm . . . As the silkworm spins a cocoon out of its own substance, so Hokhmah, the point of Beginning, expands into the palace of Binah. Cf. *Bereshit Rabbah* 21:5: "like the locust whose garment is of itself"; Shneur Zalman of Lyady, *Sha'ar ha-Yihud ve-ha-Emunah*, chapter 7, in *Liqqutei Amarim* (Brooklyn: Kehot, 1966), 81b–85a; and the spider simile in the Upanishads: Robert E. Hume, ed., *The Thirteen Principal Upanishads* (New York: Oxford University Press, 1971), 95, 367.

the unknown concealed one The hidden source of emanation, Ein Sof or Keter.

God Hebrew, Elohim. Here, as often in the *Zohar*, the name signifies Binah, the Divine Mother who gives birth to the seven lower sefirot.

The secret is . . . The *Zohar* offers its mystical reading of the opening words of the Bible. It translates the first word, *Be-Reshit*, as "With Beginning," rather than "In the beginning," relying on the fact that the Hebrew preposition *be* means "with" as well as "in." The

subject of the verse, God (Elohim), follows the verb, "created." The *Zohar*, in its typical hyperliteral fashion, insists on reading the words in the exact order in which they appear, thereby transforming God into the object! This means that there is now no subject, but that is perfect because the true subject of emanation cannot be named. For the *Zohar* the words no longer mean: "In the beginning God created," but rather: "With Beginning [by means of the point of Wisdom] the ineffable source created God [the palace of Binah]."

THE AROMA OF INFINITY

Zohar 3:26b (thirteenth century); see Matt, *Zohar*, 147, 266–68.

Ein Sof Literally, "there is no end," "Endless," Infinity. Ein Sof is the designation of the Absolute, God as infinite being, beyond the specific qualities of the sefirot.

Primordial Nothingness Aramaic, *ayin qadma'ah*. Keter, the highest sefirah, borders on Infinity and "cannot be counted" (*Zohar* 1:31b; 3:269a). It is "that which thought cannot comprehend" and is called "the annihilation of thought" (Azriel of Gerona, *Perush ha-Aggadot*, ed. Isaiah Tishby, 2d ed. [Jerusalem: Magnes Press, 1982], 40, 104). It is often referred to as Nothingness; see the introduction, pp. 7–8, and "*Ayin:* Mystical Nothingness," pp. 65–72. All of the other sefirot emerge out of this creative pool of Nothingness.

The highest point, beginning of all The second sefirah, the first that can in any way be conceived. This sefirah of Hokhmah (Wisdom) is pictured as a point of light emerging from nothingness. Cf. "The Creation of God," p. 52.

the culmination of the word Hebrew, *sof davar*, "the end of the matter, the end of the word," Ecclesiastes 12:13. Here the phrase designates Shekhinah, last of the sefirot, the culmination of divine emanation, of the divine speech act.

no end Hebrew, ein sof.

Infinity Hebrew, ein sof.

All these lights and sparks ... The nine lower sefirot are brought into being and sustained by the emanation of Ein Sof, but even they cannot comprehend Infinity. The Gnostics taught that the aeons (except for *nous*) are ignorant of the hidden God; see *The Gospel of*

Truth, in James M. Robinson, ed., *The Nag Hammadi Library in English*, 3d rev. ed. (San Francisco: Harper & Row, 1988), 40.

the highest desire The highest sefirah is also called *Ratson* (Will, Desire). Supremely hidden, it is indescribably aware of Ein Sof.

the highest point and the world that is coming The second and third sefirot, Hokhmah and Binah. The rabbinic concept of *olam ha-ba* is often understood as referring to the hereafter and is usually translated as "the world to come." However, from another perspective "the world that is coming" is already in existence, occupying another dimension. See *Tanhuma, Va-Yiqra*, 8: "The wise call it *ha-olam ha-ba* not because it is not now in existence but because for us now in this world it is still to come. So it is 'the world that comes' after one leaves this world. But one who says that this world is destroyed and afterwards ha-olam ha-ba will come—it is not so." Cf. Maimonides, *Mishneh Torah, Hilekhot Teshuvah* 8:8; and Julius Guttmann, *Philosophies of Judaism* (New York: Schocken, 1973), 37: "'The world to come' does not succeed 'this world' in time, but exists from eternity as a reality outside and above time, to which the soul ascends." The *Zohar* identifies "the world that is coming" with the sefirah of Binah, the Divine Mother who flows and engenders the seven lower sefirot. She is "the world that is coming, constantly coming and never stopping" (*Zohar* 3:290b [*Idra Zuta*]). Here Binah ascends with Hokhmah toward Ein Sof.

THE WEDDING CELEBRATION

Zohar 3:287b–288a, 291a–b, 296b (*Idra Zuta*) (thirteenth century); see Matt, *Zohar*, 182–89, 293–99.

The other time I was ill The account of Rabbi Shim'on's earlier illness is found in *Zohar Hadash, Bereshit* 18d–19a (*Midrash ha-Ne'elam*).

Rabbi Pinhas son of Ya'ir A second-century figure renowned in rabbinic literature for his saintliness and ability to work miracles. According to rabbinic tradition (Babylonian Talmud, *Shabbat* 33b), Pinhas was the son-in-law of Rabbi Shim'on, but in the *Zohar* he is promoted to the rank of Rabbi Shim'on's father-in-law; see Matt, *Zohar*, 290–91.

selecting my place in paradise next to Ahiyah of Shiloh Ahiyah was the prophet who revealed to King Jeroboam that Solomon's kingdom

would be divided; see 1 Kings 11:29–39. According to rabbinic tradition, he was a master of the secrets of Torah and the teacher of Elijah. Later, Hasidic legend portrays him as the mentor of Israel *Ba'al Shem Tov*, the founder of Hasidism. See Matt, *Zohar*, 293.

saw what he saw This phrase appears frequently in the *Zohar* in the context of mystical or prophetic vision. Here it alludes to seeing Shekhinah before one's death.

the threshing house Aramaic, *bei idra*. During the assembly at the threshing house, six of the companions proved their mystical ability and stamina, while three others died from the overwhelming power of the revelations; see *Zohar* 3:127b–145a (*Idra Rabba*); Matt, *Zohar*, 163–69, 278, 294; Yehuda Liebes, *Studies in the Zohar* (Albany: State University of New York Press, 1992), 164 and passim. Now the experienced companions are invited back to hear Rabbi Shim'on's final words. This section of the Zohar came to be called *Idra Zuta* ("The Small *Idra*") in comparison to the longer *Idra Rabba* ("The Great *Idra*"), the assembly at the threshing house.

to enter without shame into the world that is coming Displaying the knowledge of secrets removes the feeling of shame.

as a password to the world that is coming Literally, "to enter with them into the world that is coming." Cf. *Zohar* 3:291a (*Idra Zuta*): "All these words have been hidden in my heart until now. I wanted to hide them for the world that is coming, for there they ask a question and require wisdom of me. But now it is the will of the Blessed Holy One [that I reveal these words]. Behold, without shame I will enter his palace."

King Jeroboam The first ruler of the northern kingdom of Israel, who had golden calves built in Bethel and Dan to dissuade the people from going to the Temple in Jerusalem in the southern kingdom of Judah; see 1 Kings 12:25–33.

Ido the prophet . . . According to 1 Kings 13, a prophet from Judah came to Bethel and prophesied the destruction of the altar. "When King Jeroboam heard the word that the man of God had proclaimed against the altar in Bethel, he stretched out his hand above the altar and cried, 'Seize him!' But his hand that he stretched out against him dried up; he could not draw it back" (13:4). The name of the prophet is not mentioned, but he is traditionally identified as Ido.

Rav Hamnuna Sava Rabbi Hamnuna the Elder, a Babylonian teacher of the third century. The Talmud cites several prayers uttered and apparently composed by him. He is prominent in the *Zohar* and introduces several original rituals; see Matt, *Zohar*, 269, 295.

the Holy Ancient One The primal manifestation of Ein Sof, through Keter, its Crown.

all the companions speaking ... In the earlier assembly, the *Idra Rabba*, all the companions participated in revealing mystical secrets. In this assembly the companions listen as Rabbi Shim'on expounds.

'I am my beloved's, his desire is upon me' Song of Songs 7:11.

the Blessed Holy One Tif'eret, the central sefirah, less concealed than the Holy Ancient One.

nine lights The nine sefirot that emanate from the Holy Ancient One.

wedding celebration Aramaic, *hillula.* The occasion of Rabbi Shim'on's death is a wedding celebration because his soul is about to ascend and unite with Shekhinah.

the Holy Spark Aramaic, *botsina qaddisha,* "the holy lamp," Rabbi Shim'on's honorific title. In the *Zohar*, botsina means "spark, light" as well as "lamp"; see Matt, *Zohar*, 262, 296.

permission To reveal it.

"A river ... whose waters do not fail" Genesis 2:10; Isaiah 58:11. Both of these verses appear elsewhere in the *Zohar* to describe the flow of emanation. The first one is cited over fifty times.

will not miss its mark like the other day At the threshing house, when the companions participated in revealing secrets.

the High Spark Aramaic, *botsina ila'ah.* Above, this phrase denotes Rabbi Shim'on. Here it denotes the Holy Ancient One, the primal manifestation of Ein Sof through Keter, the highest sefirah. All the other sefirot ("sparks, levels") emanate from this High Spark.

Adornments of the King, Crowns of the King The *Zohar* avoids the common kabbalistic term sefirot; see Scholem, *Kabbalah*, 229; Matt, *Zohar*, 33.

It and its name is one The sefirot are God's name, the expression of divine being.

the Garment of the King Another metaphor for the sefirot.

the Ineffable One Ein Sof, the Infinite.

the Holy Ancient One Ein Sof manifesting through Keter.

there is nothing but the High Spark ... Through meditation, one discovers the ultimate reality of the High Spark. The sefirot, levels of enlightenment, are stages on the path to this realization and are ultimately seen to have no independent existence. See Matt, *Zohar*, 297.

'Length of days ... you granted it' Proverbs 3:2; Psalms 21:5.

a trundle made out of a gangplank On this bizarre phrase, see Matt, *Zohar*, 298.

Truculent stingers ... from Sepphoris Mighty Torah scholars from Sepphoris in Galilee who wanted Rabbi Shim'on buried in their city, famed for its learning; see Matt, *Zohar*, 298.

Meron The traditional site of Rabbi Shim'on's grave in Galilee.

'He shall enter in peace ... ' Isaiah 57:2; cf. Babylonian Talmud, *Ketubbot* 104a.

the cave In Meron.

'Go to the end and take your rest ... ' Daniel 12:13, the concluding verse of the book.

OBLIVION

David ben Judah he-Hasid (thirteenth–fourteenth centuries), *The Book of Mirrors: Sefer Mar'ot ha-Tsove'ot*, ed. Daniel C. Matt (Chico, CA: Scholars Press, 1982), 227; introduction, 21–22.

the depth of supernal wisdom The sefirah of Hokhmah.

forgetting pertains ... The sefirot are stages of contemplative ascent; each one serves as an object and focus of mystical search. In tracing the reality of each sefirah, the mystic uncovers layers of being within herself and throughout the cosmos. This is the knowledge that the kabbalist strives for, supernal wisdom. However, there is a higher level, a deeper realm, beyond this step-by-step approach. At the ultimate stage, the kabbalist no longer differentiates one thing from another. Conceptual thought, with all its distinctions and connections, dissolves.

Various mystics describe an experience of forgetting. Plotinus states (*Enneads*, tr. A. H. Armstrong [Cambridge, MA: Harvard University Press, 1984], 4:3:32): "The higher soul ought to be happy to forget what is has received from the worse soul.... The more it presses on toward the heights, the more it will forget." The ninth-century Sufi Abu Yazid al-Bistami, who develops the notion of *fana* ("passing away"), reports: "When God brought me to the brink of divine unity, I divorced myself and betook myself to my Lord, calling upon him to help me. 'Master,' I cried, 'I beseech thee as one to whom nothing else remains.' When he recognized the sincerity of my prayer and how I had despaired of myself, the first token that came to me proving that he had answered this prayer was that he caused me to forget myself utterly and to forget all creatures and dominions" (cited by Arthur J. Arberry, *Revelation and Reason in Islam* [London: Allen & Unwin, 1957], 96). The anonymous author of *The Cloud of Unknowing* writes (chapter 5): "You must fashion a cloud of forgetting beneath you, between you and every created thing.... Abandon them all beneath the cloud of forgetting." St. John of the Cross counsels (*Collected Works*, tr. Kieran Kavanaugh and Otilio Rodriguez [Washington: Institute of Carmelite Studies, 1973], 675): "Forgetful of all, abide in recollection with your Spouse." In a Hasidic text edited in the circle of the Maggid of Mezritch (*Shemu'ah Tovah* [Warsaw, 1938], 71b, cited by Rivka Schatz-Uffenheimer, *Ha-Hasidut ke-Mistiqah* [Jerusalem: Magnes Press, 1968], 99), we read: "Arriving at the gate of Ayin, you forget your existence altogether."

AYIN: MYSTICAL NOTHINGNESS

AYIN

First passage: David ben Abraham ha-Lavan (fourteenth century), *Masoret ha-Berit*, ed. Gershom Scholem, *Qovets al Yad* n.s. 1 (1936): 31. Second passage: Asher ben David (thirteenth century), cited by Ephraim Gottlieb, *Ha-Qabbalah be-Khitevei Rabbenu Bahya ben Asher* (Jerusalem: Kiryath Sepher, 1970), 84.

it is called Ayin David's mystical Christian contemporaries concur. The Byzantine theologian Gregory Palamas writes, "He is not being, if that which is not God is being." Meister Eckhart says, "God's *niht*

fills the entire world; his something though is nowhere." See Daniel
C. Matt, "*Ayin:* The Concept of Nothingness in Jewish Mysticism,"
in Lawrence Fine, ed., *Essential Papers on Kabbalah* (New York:
New York University Press, 1995), 67–108.

"Wisdom comes into being out of ayin" Job 28:12, usually trans-
lated: "Where is wisdom to be found?" But the Hebrew word ayin
can mean "nothing" as well as "where," and various thirteenth-cen-
tury kabbalists employ this alternate meaning. Job's rhetorical ques-
tion is thereby transformed into a mystical formula: "Divine
wisdom comes into being out of nothingness."

THE NAME OF NOTHINGNESS

Joseph Gikatilla (thirteenth century), *Sha'arei Orah* (Warsaw: Orgel-
brand, 1883), 44a–b; see Gikatilla, *Gates of Light: Sha'are Orah*, tr.
Avi Weinstein (San Francisco: HarperSanFrancisco, 1994), 160.

the belief that it exists Hebrew, *emunat metsi'uto*, perhaps modeled
on Maimonides' *amitat metsi'uto*, "the truth of its existence."

"I am becoming" Hebrew, *eheyeh*, "I will be" or "I am." In Exodus
3:14 God reveals his name to Moses: *Eheyeh asher eheyeh*, "I am
that I am" or "I will be who I will be." In Kabbalah Eheyeh is the
name of the first sefirah, usually called Keter and here referred to as
Ayin. Eheyeh conveys the unfolding, ungraspable nature of the di-
vine.

BEING AND NOTHINGNESS

Azriel of Gerona (thirteenth century), *Derekh ha-Emunah ve-
Derekh ha-Kefirah*, ed. Gershom Scholem, *"Seridim Hadashim mi-
Kitevei R. Azri'el mi-Gerona,"* in Simhah Assaf and Gershom
Scholem, eds., *Sefer Zikkaron le-Asher Gulak ve-li-Shemu'el Klein*
(Jerusalem: Hebrew University, 1942), 207. See Scholem, *Origins of
the Kabbalah*, 423–24.

"Being is in nothingness ..." Cf. the anonymous Neoplatonic *Liber
de Causis*, chapter 11: "The effect is in the cause after the mode of
the cause, and the cause is in the effect after the mode of the effect";
The Book of Causes [Liber de Causis], tr. Dennis J. Brand (Milwau-
kee, WI: Marquette University Press, 1984), 30. *Liber de Causis* was
probably known to the kabbalists in translation.

Moses de León (thirteenth century), *Sheqel ha-Qodesh*, ed. A. W. Greenup (London, 1911), 23–26.

the ten utterances ... According to Mishnah, *Avot* 5:1, God created the world with ten utterances; cf. Idel, *Kabbalah: New Perspectives*, 112–22.

the supernal chariot ... discover knowledge An allusion to the heavenly throne of God envisioned by Ezekiel (Ezekiel 1). In Kabbalah the sefirot themselves are referred to as "the supernal chariot."

highest crown The first of the sefirot, all ten of which are referred to collectively as crowns.

the pure ether that cannot be grasped See "Letters of Creation," p. 102 (*Sefer Yetsirah* 2:6): "Out of chaos God formed substance, making what is not into what is. He hewed enormous pillars out of ether that cannot be grasped," along with the corresponding note.

The belt of the wise is burst ... Their wisdom cannot comprehend this.

"Wisdom comes into being out of ayin" Job 28:12.

"The superiority of the human over the beast is ayin" Ecclesiastes 3:19. The ninth-century Christian mystic John Scotus Erigena taught that the human intellect, "while it bursts out into various forms comprehensible to the senses, does not abandon the always incomprehensible condition of its nature" (*Periphyseon* 633c). Human self-ignorance is a sign of resemblance to God: "If in any way it could understand what it is, it would necessarily deviate from the likeness of its Creator" (*Periphyseon* 585b–c).

the point of concealment ... the beginning of all existence The sefirah of wisdom, Hokhmah; cf. "The Creation of God," p. 52. On the primordial point, see Gershom Scholem, *Major Trends in Jewish Mysticism*, 173, 218. The Pythagorean philosopher Philolaus of Croton (fifth century B.C.E.) suggested that the point is the "first principle leading to magnitude."

THINK OF YOURSELF AS AYIN

Dov Baer (eighteenth century), *Maggid Devarav le-Ya'aqov*, ed. Rivka Schatz-Uffenheimer (Jerusalem: Magnes Press, 1976), 186.

Think of yourself as Ayin In this teaching of the eighteenth-century Hasidic master Dov Baer, the Maggid of Mezritch, the emphasis is no longer on the incomprehensibility and ineffability of God, but rather on the mystic's immediate awareness of nothingness. Theology turns into psychology. In the preceding selection from Moses de León, there is already an intimation of this experiential approach: the soul "stands in the status of nothingness," enabling the human being to "attain the glory of Ayin."

EFFACEMENT

Issachar Baer of Zlotshov (eighteenth century), *Mevasser Tsedeq* (Berditchev, 1817), 9a–b; see Rivka Schatz-Uffenheimer, *Ha-Hasidut ke-Mistiqah*, 114.

mitsvot "Commandments" of the Torah.

"there is no place empty of it" *Tiqqunei ha-Zohar*, 57, 91b.

Ayin, the state of humility Keter is called *anavah* ("humility") in an early kabbalistic text; see Gershom Scholem, in *Qiryat Sefer* 10 (1933–34): 507. Cf. John of the Cross, *The Ascent of Mount Carmel* 2:7: "When one is brought to nothing [*nada*]—the highest degree of humility—the spiritual union between one's soul and God will be actualized."

"Moses hid his face, for he was in awe" Exodus 3:6, describing Moses' experience at the burning bush.

THE TEN SEFIROT

THE BODY OF GOD

Shi'ur Qomah (approximately sixth century); Martin Samuel Cohen, ed., *The Shi'ur Qomah: Texts and Recensions* (Tübingen: J. C. B. Mohr, 1985), 192–94, cf. 134–48; Cohen, *The Shi'ur Qomah: Liturgy and Theurgy in Pre-Kabbalistic Jewish Mysticism* (Lanham, MD: University Press of America, 1983), 197–216.

Rabbi Ishmael A prominent rabbi of the first to second centuries. Various mystical statements and writings are ascribed to him. Another one of his visions appears in Babylonian Talmud, *Berakhot* 7a.

I saw the King ... on his right and on his left See 1 Kings 22:19; Isaiah 6:1.

The Prince of the Countenance, Metatron In Merkavah mysticism, Metatron is the highest angel, "whose name is like that of his Master" (Babylonian Talmud, *Sanhedrin* 38b). He alone is allowed to gaze directly at the face of God. See Scholem, *Kabbalah*, 377–81.

the measure of the stature Hebrew, *shi'ur qomah*. The phrase, which serves as the name of this text, can also be translated as "the measure of the body." See Cohen, *The Shi'ur Qomah: Liturgy and Theurgy in Pre-Kabbalistic Jewish Mysticism*, 77–81, 197.

parasangs The Greek parasang equals approximately 18,660 feet, or 3.5 miles. Taking this as the basic unit, the measurement here would be over 100 million miles. Among the various recensions of *Shi'ur Qomah*, there is considerable variation in the divine measurements. I have rounded off some of the following figures and have deleted the complicated divine names assigned to the limbs.

something the mouth cannot express, nor the ear hear This phrase appears in *Sefer Yetsirah* 4:12, describing the number of possible combinations of the letters of the alphabet.

His body is like aquamarine Hebrew, *geviyyato khe-tarshish*, borrowed from the vision in Daniel (10:6). The gem *tarshish* cannot be identified with any certainty; renderings include: chrysolite, ruby, topaz, opal, mother-of-pearl, and aquamarine—a transparent blue-green variety of beryl.

seventy letters Mostly permutations of the letters of the divine name YHVH.

The black of his right eye The pupil.

'the great, mighty, and awesome God' Deuteronomy 10:17.

three miles Other versions read "four miles." As noted above, a Greek parasang equals about three-and-a-half miles.

10,000 cubits A human cubit (*ammah*) is the distance from the tip of the middle finger to the elbow, about eighteen inches. Ten thousand cubits comes to some 15,000 feet, or about three miles, about three times too much. This and other inconsistencies in *Shi'ur Qomah* are due to several factors. First of all, different measurements of length

were assigned at various times and locations to these units (parasang, mile, cubit, span). Secondly, the various manuscripts of *Shi'ur Qomah* provide a wide range of conflicting total amounts of these units. The inconsistencies, though—along with the measurements themselves—pale in the light at the end of the sentence.

two spans A human span (*zeret*) measures about nine inches.

God's span, which spans the entire universe See Isaiah 40:12: "Who measured the waters with the hollow of his hand, and gauged the skies with a span?" quoted at the end of this passage in *Shi'ur Qomah*. The divine span itself, the smallest unit of measurement, is nearly infinite; thus all the enormous calculations detailed above are rendered even more fantastic, in fact, absurd. The goal in trying to depict God is to fail—and thereby to realize the infinity of God.

THE TEN SEFIROT

Sefer Yetsirah 1:1–8 (third–sixth centuries). I have relied primarily on Vatican manuscript 299, considered the oldest and best. Among the editions and translations consulted are the following: *Sefer Yetsirah* (Jerusalem: Lewin-Epstein, 1965); Ithamar Gruenwald, "A Preliminary Critical Edition of *Sefer Yezira*," in *Israel Oriental Studies* 1 (1971): 132-77; Gruenwald, "Some Critical Notes on the First Part of *Sefer Yezira*," *Revue des Études Juives* 132 (1973): 475–512; Israel Weinstock, in *Temirin*, vol. 1, ed. Israel Weinstock (Jerusalem: Mossad ha-Rav Kook, 1972), 9–61; David R. Blumenthal, *Understanding Jewish Mysticism: A Source Reader* (New York: Ktav, 1978), 13–46; Aryeh Kaplan, *Sefer Yetzirah: The Book of Creation*; Ben Zion Bokser, *The Jewish Mystical Tradition* (New York: Pilgrim Press, 1981), 65–67.

Yah YHVH Tseva'ot A triple divine name. Yah is an abbreviated form of YHVH; Tseva'ot is usually translated "hosts."

thirty-two wondrous paths of wisdom The thirty-two paths are identified in the following sentence.

in three ciphers: boundary, language, and number Literally, "in three books [*sefarim*]: SFR, SFR, SFR." The nature of these three volumes is quite unclear, nor is there any agreement on how to vocalize the triple SFR, though it obviously resonates with the neologism sefirot in the next line. Among the various renderings: "by three principles: by border and letter and number" (Blumenthal); "comprising three

categories: numbers, letters, and words" (Bokser); "with three books: with text, with number, and with communication" (Kaplan); "in three books" (Gruenwald). Gruenwald chooses, wisely perhaps, not to translate the triple SFR, though he records a kabbalistic tradition that all three share the same vocalization. The phrase points to the basic teaching of *Sefer Yetsirah:* God creates and determines the universe through word and number.

ten *sefirot belimah* The term sefirot, which becomes central in Kabbalah, appears here in the opening chapter of *Sefer Yetsirah* for the first time. Its meaning, intentionally obscure, is perhaps "numerical entities," the metaphysical principles of the numbers one through ten. Gradually, between the composition of *Sefer Yetsirah* and the twelfth century, the sefirot evolve into various manifestations of divine personality. The word *belimah*, also obscure, can be read as two words: *beli mah*, "without what." It appears once in the Bible in the book of Job (26:7): "He stretches the north over chaos and suspends the earth over belimah," meaning apparently "emptiness" or "nothingness," the cosmic void. The sefirot are without whatness; they cannot be grasped. A few paragraphs later, we find belimah followed immediately by the imperative *belom*, "bridle, restrain": "Ten sefirot belimah. Belom, Bridle your mind from imagining, your mouth from speaking." The phrase sefirot belimah conveys a sense of concealment and mystery.

twenty-two elemental letters The twenty-two letters of the Hebrew alphabet. Thus God created the world through numbers and letters, a cosmology combining the biblical view of creation by divine speech with the Pythagorean theory that numbers constitute the essential nature of things.

circumcision According to Genesis (17:1–14), circumcision was "the sign of the covenant" between God and Abraham, between God and all of Abraham's descendants.

restore the Creator to his abode By probing and contemplating the sefirot, one discovers the divine reality and thereby enthrones God.

"The creatures darting to and fro" Ezekiel 1:14, describing the celestial creatures carrying the divine throne.

a covenant has been made A covenant of secrecy.

Their end is embedded in their beginning, their beginning in their end The circular description of the sefirot recalls the *uroboros*, the

Ophitic depiction of the universe in the form of a snake swallowing its tail. Alternatively, each sefirah is inseparable from the preceding and following sefirot, like a flame joined to a burning coal.

Depth of beginning, depth of end The dimension of time.

depth of good, depth of evil The moral dimension.

depth of above ... depth of south The dimension of space.

God alone rules them all Here in *Sefer Yetsirah*, God appears to be separate from the sefirot. In subsequent kabbalistic literature, the sefirot themselves are divine, while Ein Sof, Infinity, both transcends and animates them.

flashing like lightning See Ezekiel 1:14: "The celestial creatures darting to and fro with the appearance of a flash of lightning."

THE COSMIC TREE

Sefer ha-Bahir (twelfth century), ed. Reuben Margaliot (Jerusalem: Mossad ha-Rav Kook, 1978), Sec. 22, 11; see Scholem, *Origins of the Kabbalah*, 68–80; Elliot R. Wolfson, "The Tree That Is All: Jewish-Christian Roots of a Kabbalistic Symbol in *Sefer ha-Bahir*," *Journal of Jewish Thought and Philosophy* 3 (1993): 31–76.

this tree The cosmic tree, source of life for the entire universe. Elsewhere (Sec. 119) the *Bahir* identifies this tree with the sefirot: "What is this tree? The powers of God, one above the other, resembling a tree."

the All Hebrew, *kol*. In Gnosticism the All (Greek, *to pan, to holon*) is the name for the divine pleroma, or fullness, a world of perfection and absolute harmony.

From here souls fly forth in joy All souls emerge from the cosmic tree.

giving them joy in one another The earth and the tree.

THE RIGHTEOUS PILLAR

Sefer ha-Bahir, Sec. 102, 44 (twelfth century).

"The righteous one is the foundation of the world" Hebrew, *ve-tsaddiq yesod olam* (Proverbs 10:25), which in Proverbs means: "The righteous person is an everlasting foundation." The Hebrew word

olam means both "eternity" and "world," all of time and all of space. The *Bahir* adopts the latter meaning; cf. Babylonian Talmud, *Hagigah* 12b: "The earth stands on one pillar named Righteous, as it is written: 'The righteous one is the foundation of the world.'" In the *Bahir* and subsequently, the cosmic pillar is identified with the sefirah of Yesod (Foundation), also known as *Tsaddiq*.

that person sustains the world Cf. Babylonian Talmud, *Yoma* 38b: "For the sake of even one righteous person, the world endures, as it is written: 'The righteous one is the foundation of the world.'" See Arthur Green, "The *Zaddiq* as *Axis Mundi* in Later Judaism," *Journal of the American Academy of Religion* 45 (1977): 327–47. Human righteous action affects not only life on earth but the entire structure of the cosmos.

THE POWER OF THE RIGHTEOUS

Joseph Gikatilla (thirteenth century), *Sha'arei Orah*, 19a–b; see Gikatilla, *Gates of Light: Sha'are Orah*, tr. Avi Weinstein, 61–63.

The Righteous One The ninth sefirah, also known as Yesod, Foundation. He includes the emanation of all the higher sefirot and channels this flow toward the final sefirah, Malkhut (Kingdom), also known as Shekhinah, the feminine divine presence.

in order to reward those purifying themselves ... Shekhinah transmits the flow of blessing to the lower worlds and to humanity.

THE SECRET OF SABBATH

Zohar 2:135a–b (thirteenth century); see Matt, *Zohar*, 132, 257–58.

She is Sabbath Shekhinah is the Sabbath Queen entering the palace of time every Friday evening at sunset. As the seventh sefirah below Binah, Shekhinah is the seventh primordial day. Friday evening is the time of her union with her masculine counterpart, the sefirah of Tif'eret. The Sabbath is God's wedding celebration.

United in the secret of one ... Shekhinah and her angels of escort join together in "the secret of one" in preparation for her encounter with Tif'eret, who has joined together with the sefirot surrounding him in a corresponding "secret of one." Shekhinah and Tif'eret must each be whole before they can unite.

the Other Side Aramaic, *sitra ahra*, the demonic realm, which threatens Shekhinah and humanity on the weekdays. Once Sabbath begins, Shekhinah is safe and provides blessing openly to the world.

she is crowned over and over to face the holy King The Sabbath is referred to as Queen in Babylonian Talmud, *Shabbat* 119a: "Rabbi Hanina used to wrap himself in a garment, stand close to sunset as Sabbath entered, and say: 'Come, let us go out to greet Sabbath, the Queen.' Rabbi Yannai would put on special clothes as Sabbath entered and say: 'Come, O Bride! Come, O Bride!'" Here in the *Zohar*, Shekhinah, the Sabbath Queen, prepares to meet King Tif'eret.

All powers of wrath ... Once Sabbath has entered, the power of strict judgment disappears. According to Babylonian Talmud, *Sanhedrin* 65b, even the wicked in hell are granted rest on the Sabbath.

she is crowned below by holy people By welcoming the Sabbath Bride and celebrating her arrival, human beings array her for the union with Tif'eret.

all of whom are crowned with new souls According to Rabbi Shim'on ben Laqish (Babylonian Talmud, *Beitsah* 16a), "The Blessed Holy One gives an extra soul to a human being on the eve of Sabbath. When Sabbath departs, it is taken away." The extra soul enables one to leave behind the turmoil of the week, to experience the joy and depth of Sabbath. Cf. *Zohar* 2:136b: "Every Friday evening, a human being sits in the world of souls."

HUMAN AND DIVINE LIMBS

Joseph Gikatilla (thirteenth century), *Sha'arei Orah*, 2a–b; see Gikatilla, *Gates of Light: Sha'are Orah*, tr. Avi Weinstein, 7–8.

"Blessed be the presence ..." Ezekiel 3:12, recited daily in the central prayer, the *qedushah*. Cf. Babylonian Talmud, *Hagigah* 13b: "It is written: 'Blessed be the presence of YHVH in his place,' because no one knows his place." See Matt, *Zohar*, 65, 221.

inner—innermost—aspects of the divine reality ... The sefirot, aspects of the divine personality, such as wisdom, understanding, love, rigor, and beauty. Each of these is pictured as one organ or limb of an androgynous divine being. Together they conduct the flow of emanation to the world.

"To whom can I be compared?" Isaiah 40:25.

the particular entity called by that name Our organs and limbs are symbols of the various sefirot. The difference between human and divine limbs is like the difference between the letters "Reuben son of Jacob" and the real person behind the name.

purifying a particular organ or limb ... By acting ethically and righteously, one can purify oneself and become a channel for the divine. The sefirot manifest through the body and being of such a person. Cf. the Islamic *hadith qudsi* (in Annemarie Schimmel, *Mystical Dimensions of Islam* [Chapel Hill, NC: University of North Carolina Press, 1975], 43): "God most high has said: 'When I love a servant, I, the Lord, am his ear, so that he hears by me; I am his eye, so that he sees by me; I am his tongue, so that he speaks by me; and I am his hand, so that he takes by me.'"

THE PALM TREE OF DEBORAH

Moses Cordovero (sixteenth century), *Tomer Devorah* (Warsaw: Joel Levensohn, 1873), 1 (7a, 8b–9a, 10a–11a, 13b–14a); 2 (14a–16b, 17b); 3 (18a–19b); 4 (20a–b); 5 (20b–21a). See Cordovero, *The Palm Tree of Deborah*, tr. Louis Jacobs (New York: Sepher-Hermon Press, 1974).

the supernal form The sefirot, arranged in the form of *Adam Qadmon*, the primordial, androgynous archetype of the human being.

the divine image in which you were created See Genesis 1:26: "Let us make *adam* in our image and likeness." The sefirot constitute the archetype of this image.

the essence of the divine image is action The sefirot manifest in the world as divine activity, ranging from love to judgment.

the acts of Keter, the thirteen qualities of compassion Keter, the highest sefirah, is a realm of total compassion untainted by judgment. The kabbalists derive its various qualities of compassion from the closing verses of the book of Micah (7:18–20). In earlier, rabbinic tradition, God's thirteen attributes of compassion are derived from Exodus 34:6–7; see Babylonian Talmud, *Rosh ha-Shanah* 17b.

Let his honor be as precious to you as your own A paraphrase of Mishnah, *Avot* 2:10.

"Love your neighbor as yourself" Leviticus 19:18.

"Those who return to God ... " Babylonian Talmud, *Berakhot* 34b.

Keter transcends all the other qualities Keter, the highest sefirah, transcends all the other sefirot.

Its emanator Ein Sof.

from the horned buffalo to nits According to Rav (Babylonian Talmud, *Avodah Zarah* 3b), God's daylight schedule is as follows: "For the first three hours the Holy One, blessed be he, sits and studies Torah. For the next three he sits and judges the entire world. Once he determines that the world deserves to be destroyed, he rises from the seat of Judgment and moves to the seat of Compassion. For the next three hours he feeds the entire world, from the horned buffalo to nits. For the last three hours he plays with Leviathan."

the forehead of the Will Keter, the "Crown" or head of the sefirot, is also the divine Will. Its forehead manifests compassion.

the harsh powers Hebrew, *ha-gevurot*, powers of harsh judgment.

the Ancient One The primal manifestation of Ein Sof through its first sefirah, Keter.

"If the spirit of people delights in someone, so does the spirit of God." Mishnah, *Avot* 3:11.

tongue of evil Hebrew, *leshon ha-ra*, "evil tongue" or "tongue of evil," "evil talk," the rabbinic term for gossip and slander.

"In the light of the king's face is life." Proverbs 16:15. Cf. Mishnah, *Avot* 1:15: "Welcome each person with a friendly countenance."

redness The color of harsh judgment.

"How manifold are your works, O God ... " Psalms 104:24.

powers of judgment Hebrew, *dinim*, powers of the sefirah of Din, harsh judgment.

your intentional sins turn into merits According to rabbinic teaching (Babylonian Talmud, *Yoma* 86b), turning back to God and repenting in love have the effect of transforming intentional sins into merits.

the Left Side The demonic dimension, which branches out from the sefirah of Din, harsh judgment, located on the left side of the sefirotic tree.

"Who is a *hasid*? ... " *Zohar* 2:114b *(Ra'aya Meheimna)*; *Tiqqunei ha-Zohar*, introduction, 1b.

mending up above, after the same pattern Acts of love on earth have their effect above in the world of the sefirot, uniting the various aspects of God.

CREATION

THE HIDDEN LIGHT

Zohar 1:31b–32a; 2:148b–149a (thirteenth century); see Matt, *Zohar*, 51–53, 210–14.

God said, "Let there be light!"... Genesis 1:3–4.

'Light is sown for the righteous' Psalms 97:11. Cf. *Midrash Tanhuma, Shemini* 9: Rabbi Judah son of Simon said, "With the light created by God on the first day, Adam could gaze and see from one end of the universe to the other. Since God foresaw the corrupt deeds of the generation of Enosh and the generation of the Flood, he hid the light from them. Where did he hide it? In the Garden of Eden for the righteous, as it is written: 'Light is sown for the righteous.'" Cf. *Bahir*, Sec. 160: "Before the world was created, an impulse arose in the divine mind to create a great shining light. A light so bright was created that no creature could control it. When God saw that no one could bear it, he took one-seventh and gave it to them in its place. The rest he hid away for the righteous in the time to come, saying, 'If they prove worthy of this seventh and guard it, I will give them the rest in the final world.'"

absorbed in her In Torah; see Matt, *Zohar*, 2, 213–14. Cf. Babylonian Talmud, *Hagigah* 12b: Reish Laqish said, "Whoever engages in Torah at night, the Blessed Holy One extends a thread-thin ray of love to him during the day." The Ba'al Shem Tov, founder of Hasidism, is reported to have said: "With the light of the six days of Creation, one could see from one end of the universe to the other. Where did God hide it? In the Torah. Whoever attains the light hidden in the Torah can see from one end of the world to the other." According to another version of this saying, the last sentence reads: "So when I open the *Zohar*, I see the whole world."

renewing each day the act of Creation Cf. the morning prayer: "Lord of wonders, who renews in his goodness every day continually the act of Creation."

First passage: Moses Cordovero (sixteenth century), *Pardes Rimmonim*, 5:4, 25d. Second passage: Shim'on Lavi (sixteenth century), *Ketem Paz* (Jerusalem: Ahavat Shalom, 1981), 1:124c.

THE DIVINE BREATH

First passage: Shabbetai Donnolo (tenth century), *Sefer Hakhmoni*, ed. David Castelli, on *Sefer Yetsirah* 1:10, in *Sefer Yetsirah* (Jerusalem: Lewin-Epstein, 1965), 67b; paraphrased by Shim'on Lavi, *Ketem Paz*, 1:49d. See Boaz Huss, in *Mehqerei Yerushalayim be-Mahashevet Yisra'el* 10 (1992): 359–60. Second passage: cited by Shem Tov ibn Shem Tov (fourteenth–fifteenth centuries) from "the writings of the kabbalists." See Scholem, *Origins of the Kabbalah*, 450, n. 202; Scholem, *Kabbalah*, 129; Moshe Idel, "On the Concept of *Tsimtsum*" (Hebrew), in *Mehqerei Yerushalayim be-Mahashevet Yisra'el* 10 (1992): 69.

"Enough!" Hebrew, *dai*. In rabbinic literature (Babylonian Talmud, *Hagigah* 12a), the divine name Shaddai is interpreted as: the one who said "Dai" (enough), thus placing a limit on the initial expansion of the cosmos.

to a divine handbreadth According to the Midrash, God contracted his presence, his Shekhinah, in the Tabernacle that accompanied the children of Israel in the wilderness of Sinai. The Shekhinah was concentrated especially at the ark of the covenant (*Tanhuma, Va-Yaqhel*, 7). On top of the ark was a gold cover flanked by two cherubs hammered out at either end. The divine voice spoke to Moses "from above the cover, from between the two cherubs" (Exodus 25:22; cf. Numbers 7:89). The cover itself was one handbreadth thick (Babylonian Talmud, *Sanhedrin* 7a); thus it can be said that in the Tabernacle God contracted his presence to a handbreadth. In our passage, God concentrates or contracts (Hebrew *tsimtsem*) the divine light to a divine handbreadth, withdrawing it from the rest of space, which turns dark. This act of withdrawal, or inhalation, is the first step in the process of emanation.

TSIMTSUM: CREATIVE WITHDRAWAL

First passage: Moses Nahmanides (thirteenth century), *Commentary on Sefer Yetsirah*, ed. Gershom Scholem, in *Qiryat Sefer* 6 (1929):

402–3; cf. Scholem, *Origins of the Kabbalah*, 450; Idel, "On the Concept of *Tsimtsum*" (Hebrew), 60–68. Second passage: Shabbetai Sheftel Horowitz (sixteenth–seventeenth centuries), *Shefa Tal* (Lemberg, 1859), 3:5, 57b.

in thirty-two paths See "The Ten *Sefirot*," p. 76 (*Sefer Yetsirah* 1:1): "thirty-two wondrous paths of wisdom."

withdrew Hebrew, *tsimtsem*, "contracted, concentrated," but here meaning "retracted, withdrew." The concept of tsimtsum, adumbrated in early Kabbalah (see the preceding selections), was developed by Moses Cordovero and Isaac Luria. This initial withdrawal of the divine presence creates a vacuum into which emanation proceeds; see the introduction, pp. 14–15.

TSIMTSUM AND SHEVIRAH: WITHDRAWAL AND SHATTERING

Hayyim Vital (sixteenth–seventeenth centuries), "On the World of Emanation," in *Liqqutim Hadashim* (Jerusalem: Mevaqqeshei ha-Shem, 1985), 17–23.

a vacuum According to other accounts, this vacuum was not absolute, since there remained a trace [*reshimu*] of divine light; see Scholem, *Kabbalah*, 130–31.

judgment The quality of limitation and definition, without which nothing could exist as a separate entity.

an amorphous mass Hebrew, *golem*; see Moshe Idel, *Golem: Jewish Magical and Mystical Traditions on the Artificial Anthropoid* (Albany: State University of New York Press, 1990), 145–47.

emanation, creation, formation, and actualization On these four worlds, see "*Ein Sof* and the *Sefirot*," pp. 48–49; Scholem, *Kabbalah*, 118–19.

the mother's womb Corresponding to the divine mother, Binah.

the world of creation The second of the four worlds.

regenerated, arrayed anew Hebrew, *be-tiqqun*. Tiqqun means "mending, repair, restoration" and refers to the process of repairing the shattering of the vessels.

the end of the world of emanation The last of the ten sefirot.

visages Hebrew, *partsufim*, "faces, aspects, configurations, gestalts." These five visages manifest distinctive aspects of divinity: Patient

One, Father, Mother, Impatient One, and Feminine. They correspond, respectively, to the following sefirot: Keter, Hokhmah, Binah, Tif'eret and the five sefirot surrounding him (Hesed, Gevurah, Netsah, Hod, and Yesod), and Malkhut.

SHATTERING AND GROWTH

Menahem Azariah of Fano (sixteenth–seventeenth centuries), "On the *Tehiru*," printed at the beginning of his *Yonat Elem*; see Gershom Scholem, *Sabbatai Sevi: The Mystical Messiah* (Princeton: Princeton University Press, 1973), 35.

vacuum Aramaic, *tehiru*, "purity, brilliance." In the *Zohar* (1:15a; see "The Creation of God," p. 52) the tehiru is the luster enveloping, as it were, Ein Sof: "When the King conceived ordaining, he engraved engravings in the supernal tehiru." In Lurianic Kabbalah this pure brilliance is described as being removed from a point in the middle of Ein Sof through the primal act of divine withdrawal, tsimtsum; see the preceding passage and the introduction, p. 15. This withdrawal produces an empty space, a vacuum, known as tehiru, which, according to some accounts, actually retains a faint residue of divine light. The emanation proceeds into this vacuum.

ten points of light The ten sefirot.

configurations Hebrew, *partsufim*, "faces, aspects, configurations, gestalts, or, as translated earlier, visages." These five configurations manifest distinctive aspects of divinity: Patient One, Father, Mother, Impatient One, and Feminine. They correspond, respectively, to the following sefirot: Keter, Hokhmah, Binah, Tif'eret and the five sefirot surrounding him (Hesed, Gevurah, Netsah, Hod, and Yesod), and Malkhut.

TRACES

Israel Sarug (sixteenth–seventeenth centuries), *Limmudei Atsilut* (Munkacs, 1897), 4d; see Scholem, *Sabbatai Sevi*, 40–41.

the world of actualization Hebrew, *olam ha-asiyyah*, the last of the four worlds, preceded by the worlds of emanation, creation, and formation.

CREATIVE AROUSAL

Naftali Bacharach (seventeenth century), *Emeq ha-Melekh* (Amsterdam, 1648), 1:2, 1d–2d. See Yehuda Liebes, "Toward a Study of the Author of *Emeq ha-Melekh*" (Hebrew), in *Mehqerei Yerushalayim be-Mahashevet Yisra'el* 11 (1993): 117–18.

by virtue of Hebrew, *bi-zekhut*, "on the merit of," due to the influence of righteous conduct.

who would eventually be Literally, "who would eventually be his." The reference is to Israel, the holy nation.

RENEWAL

Abraham Isaac Kook (twentieth century), *Orot ha-Qodesh*, 2:517.

LETTERS OF THE ALPHABET

LETTERS OF CREATION

Sefer Yetsirah 2:2, 4–6; 6:4 (third–sixth centuries). Among the editions and translations consulted are the following: *Sefer Yetsirah* (Jerusalem: Lewin-Epstein, 1965); Gruenwald, "A Preliminary Critical Edition of *Sefer Yezira*," in *Israel Oriental Studies* 1 (1971): 132–77; Blumenthal, *Understanding Jewish Mysticism: A Source Reader*, 13–46; Kaplan, *Sefer Yetzirah: The Book of Creation*.

Twenty-two elemental letters the letters of the Hebrew alphabet. See the selections from the previous chapter of *Sefer Yetsirah*, "The Ten *Sefirot*," p. 76.

permuted them . . . everything destined to be formed God creates by combining and arranging the letters of the Hebrew alphabet in all possible ways. Many kabbalists, including Abraham Abulafia, sought to imitate this activity of letter permutation, based on the detailed instructions in *Sefer Yetsirah*.

231 gates The number of two-letter combinations that can be formed from the twenty-two letters of the Hebrew alphabet, provided the same letter is not repeated. For details and charts, see

Blumenthal, *Understanding Jewish Mysticism*, 22–30; Kaplan, *Sefer Yetzirah*, 108–24.

from one name The entire alphabet seen as one name. Alternatively, the name is YHVH; see Scholem, *Kabbalah*, 25; Kaplan, *Sefer Yetzirah*, 125–31.

ether that cannot be grasped The concept of the ether (Hebrew, *avir*, "air") corresponds to Greek conceptions. Aristotle identified ether as an incorruptible, unchanging heavenly element found only in the region beyond the sphere of the moon. Rotating around the earth, the ether fills all of space. All the heavenly bodies—the sun, moon, planets, and stars—are composed of it, as are the rotating spheres in which these ethereal bodies are embedded. The Stoics identified the ether with *pneuma*, a quasi-material spiritual substance, which pervades not only heaven but all matter on earth, as well as transmitting light and gravity. Descartes' "subtle matter" corresponds to the ether, as does the active vacuum field in contemporary particle physics. See Mary Hesse, "Ether," in Paul Edwards, ed., *The Encyclopedia of Philosophy* (New York: Macmillan, 1967), 3:66–69. In classical Kabbalah the ether is identical with the highest sefirah, also known as nothingness—the creative nothingness out of which all being emerges.

"Abraham, my beloved" Isaiah 41:8. In imitating the divine act of creating with letters, Abraham becomes a model for later Jewish mystics. Traditionally, *Sefer Yetsirah* is attributed to Abraham.

UNSHEATHING THE SOUL

Abraham Abulafia (thirteenth century), *Hayyei ha-Olam ha-Ba*, in Adolph Jellinek, *Philosophie und Kabbala, Erstes Heft* (Leipzig: Heinrich Hunger, 1854), 44–45; cf. Gershom Scholem, *Ha-Qabbalah shel Sefer ha-Temunah ve-shel Avraham Abulafia* (Jerusalem: Akademon, 1969), 210–11; Scholem, *Major Trends in Jewish Mysticism*, 136–37.

tallit Prayer shawl.

tefillin Phylacteries.

Shekhinah The divine presence.

Begin to combine letters The letters of the Hebrew alphabet.

visualizing the Name YHVH. See Moshe Idel, *The Mystical Experience in Abraham Abulafia* (Albany: State University of New York Press, 1988), 31–32.

like Moses at the burning bush See Exodus 3:5–6: "God said, 'Come no closer. . . .' And Moses hid his face, for he was afraid to look at God."

THE PROOF OF WISDOM

Sha'arei Tsedeq, by an anonymous student of Abraham Abulafia (thirteenth century). See Scholem, in *Qiryat Sefer* 1 (1924–25), 127–39; Scholem, *Major Trends in Jewish Mysticism,* 146–55.

Guide of the Perplexed The best-known work of medieval Jewish philosophy, written by Maimonides in the twelfth century and studied avidly by many early kabbalists, especially Abraham Abulafia.

how to permute the letters ... Sefer Yetsirah These are methods of meditating on the letters of the Hebrew alphabet by combining and rearranging them in various ways. Such letter combination was Abulafia's basic meditative technique; see Idel, *The Mystical Experience in Abraham Abulafia,* passim. On *Sefer Yetsirah,* see the introduction, pp. 4–5, and "Letters of Creation," p. 102.

to erase everything Hebrew, *li-mehoq ha-kol.* Earlier in his account, this student of Abulafia refers to the Sufi technique of erasure or effacement (Hebrew, *mehiqah;* Arabic, *mahw*), by which the spiritual adept empties his mind of "all the natural forms" (sensible images). See Scholem, *Major Trends in Jewish Mysticism,* 147; 384, n. 105.

The less comprehensible, the higher The various combinations of letters are not intended to make sense but, rather, to liberate the mind from rational forms of thought.

an energy Hebrew, *pe'ulat ha-koah,* "the activity of the force."

knowledge of the Name Knowledge of the divine name: YHVH.

had been stripped Of sensible images.

ALONENESS AND ABUNDANCE

Isaac of Akko (thirteenth–fourteenth centuries), *Otsar Hayyim,* Moscow-Guenzburg manuscript 775, 1a–2a.

more than the calf wants to suck, the cow wants to suckle. One of the five things that the imprisoned Rabbi Akiva taught Rabbi Shim'on bar Yohai; see Babylonian Talmud, *Pesahim* 112a.

aloneness Hebrew, *hitbodedut,* "aloneness," contemplative concentration.

the diadem Hebrew, *ateret,* the last of the ten sefirot, often referred to as Malkhut, "kingdom." The six sefirot from Hesed to Yesod flow into the diadem.

the three upper sefirot Keter, Hokhmah, and Binah.

to Moses The figure of Moses conveys the flow of emanation from the sefirot to the soul.

Sefer Yetsirah 1:8; see "The Ten *Sefirot,*" p. 76.

MIND, MEDITATION, AND MYSTICAL EXPERIENCE

IMAGINE THAT YOU ARE LIGHT

Sha'ar ha-Kavvanah, attributed to Azriel of Gerona (thirteenth century); see Gershom Scholem, *Reshit ha-Qabbalah* (Jerusalem: Schocken, 1948), 143–44; Scholem, *Origins of the Kabbalah,* 417–18; Idel, *The Mystical Experience in Abraham Abulafia,* 60.

your intention to be true Hebrew, *le-khavven davar la-amitto.* A *kavvanah* is a meditative intention directed to a particular word of prayer, divine name, or divine quality.

AN EXTRA SPIRIT

Abraham Abulafia (thirteenth century), *Otsar Eden Ganuz;* see Idel, *The Mystical Experience in Abraham Abulafia,* 188; Idel, *The Mystical Experience in Abraham Abulafia,* Hebrew edition, 140.

JOINING THE DIVINE

First passage: Azriel of Gerona (thirteenth century), *Perush ha-Aggadot,* 20. Second passage: Isaac of Akko (thirteenth–fourteenth centuries), *Otsar Hayyim,* Moscow-Guenzburg manuscript 775, 111a; see Ephraim Gottlieb, *Mehqarim be-Siftrut ha-Qabbalah,* ed.

Joseph Hacker (Tel Aviv: Tel Aviv University, 1976), 237; Idel, *Kabbalah: New Perspectives*, 67; 306, n. 65.

Say to Wisdom, "You are my sister." Proverbs 7:4.

Taste and see that God is good Psalms 34:9.

more than the calf wants to suck, the cow wants to suckle One of the five things that the imprisoned Rabbi Akiva taught Rabbi Shim'on bar Yohai; see Babylonian Talmud, *Pesahim* 112a; "Aloneness and Abundance," p. 108.

THE MIRROR OF THOUGHT

Azriel of Gerona (thirteenth century), *Perush ha-Aggadot*, 93.

THE ANNIHILATION OF THOUGHT

Azriel of Gerona (thirteenth century), *Perush ha-Aggadot*, 116. Both Azriel and his older contemporary, Ezra of Gerona, call the highest sefirah "the annihilation of thought" (*afisat ha-mahashavah*); see Azriel, *Perush ha-Aggadot*, 40.

BEYOND KNOWING

Isaac the Blind (twelfth–thirteenth centuries), *Commentary on Sefer Yetsirah*, ed. Gershom Scholem, *Ha-Qabbalah be-Provans* (Jerusalem: Akademon, 1970), appendix, 1.

only by sucking, not by knowing At this stage of contemplation, the mystic cannot grasp for knowledge; rather, he imbibes from the source to which he is joined. Cf. Isaac of Akko, *Commentary on Sefer Yetsirah* (ed. Scholem, *Qiryat Sefer* 31 [1956]: 383): "No creature can understand the hidden paths of wisdom except through contemplative thought—not through knowing, through the effort of study, but rather through contemplation."

RIPPLES

Moses de León (thirteenth century), *Commentary on the Sefirot*, published by Gershom Scholem, *"Eine unbekannte mystische Schrift des Mose de Leon,"* in *Monatsschrift für Geschichte und Wissenschaft des Judentums* 71 (1927): 118–19, n. 5; see Idel, *Kabbalah: New Perspectives*, 140.

You keep pursuing it Cf. Moses de León, *Sheqel ha-Qodesh*, 113: "If you take a bowl of water and place it in the sunlight and ripple it, you will find on the wall a radiance like shining mirrors flashing back and forth. The light moves so fast, no one can detain it."

MENTAL ATTACHMENT

Isaac of Akko (thirteenth–fourteenth centuries), *Otsar Hayyim*, Moscow-Guenzburg manuscript 775, 7a; see Gottlieb, *Mehqarim be-Sifrut ha-Qabbalah*, 240.

IMAGINATION

Abraham Isaac Kook (twentieth century), *Orot ha-Qodesh*, 1:262.

GATHERING MULTIPLICITY

Azriel of Gerona (thirteenth century), *Sod ha-Tefillah*, ed. Gershom Scholem, "*Seridim Hadashim*," 216. In his *Perush ha-Aggadot*, 82–83, Azriel cites the identical teaching in the name of Plato.

the root of roots The hiddenness of God.

the form of forms The concrete form of the material world.

gather the multiplicity Plotinus (*Enneads* 4:3:32) notes that "the higher soul gathers multiplicity into one. In this way it will not be [clogged] with multiplicity but light and alone by itself."

EQUANIMITY

Isaac of Akko (thirteenth–fourteenth centuries), *Me'irat Einayim*, ed. Amos Goldreich (Jerusalem: Hebrew University, 1981), 218; see Idel, *Kabbalah: New Perspectives*, 49–50; 295, n. 92; Idel, "*Hitbodedut* as Concentration in Ecstatic Kabbalah," in Arthur Green, ed., *Jewish Spirituality: From the Bible through the Middle Ages* (New York: Crossroad, 1986), 407–9, 414–15.

aloneness Hebrew, hitbodedut, "aloneness," contemplative concentration. In *Enneads* 6:9:11 Plotinus speaks of "the flight of the alone to the alone."

one who secluded himself in meditation Hebrew, *ehad me-ha-mitbodedim*, "one of those who practice hitbodedut" (see above).

An anonymous thirteenth-century text apparently from Gerona; see Gershom Scholem, "The Concept of *Kavvanah* in the Early Kabbalah," in Alfred Jospe, ed., *Studies in Jewish Thought* (Detroit: Wayne State University Press, 1981), 168; 178, n. 38; Idel, *Kabbalah: New Perspectives*, 53–54; 297, n. 117.

Those who practice aloneness Hebrew, mitbodedim, those who practice hitbodedut, "aloneness," contemplative concentration.

the divine name YHVH, whose letters symbolize the ten sefirot. By meditating on the letters of this divine name, one is able to unify the sefirot.

the source of the infinitely sublime flame Ein Sof, the Infinite.

GAZING AT THE LETTERS

Isaac of Akko (thirteenth–fourteenth centuries), *Me'irat Einayim*, 217; see Gottlieb, *Mehqarim be-Sifrut ha-Qabbalah*, 235.

you attain incessantly the world that is coming The rabbinic concept of olam ha-ba is often understood as referring to the hereafter and is usually translated as "the world to come." However, from another perspective "the world that is coming" is already in existence, occupying another dimension. The Kabbalah identifies "the world that is coming" with the sefirah of Binah, the Divine Mother who flows and engenders the seven lower sefirot. She is "the world that is coming, constantly coming and never stopping" (*Zohar* 3:290b [*Idra Zuta*]). Here Isaac of Akko indicates the possibility of experiencing the divine flow constantly.

God's name Hebrew, *ha-shem ha-meyuhad*, "the distinguished [or "unique"] name," referring to the Tetragrammaton: YHVH.

CLIMBING THE LADDER

Isaac of Akko (thirteenth–fourteenth centuries), *Otsar Hayyim*, Moscow-Guenzberg manuscript 775, 100a; see Gottlieb, *Mehqarim be-Sifrut ha-Qabbalah*, 236.

the great one of his generation The referent is uncertain.

"I set YHVH before me always." Psalms 16:8. In the Kabbalah this verse turns into a description of meditation on the divine name

YHVH. Each letter of this name symbolizes a sefirah or several se-
firot; see "*Ein Sof* and the *Sefirot*," p. 49.

emanation, creation, formation, and actualization *Atsilut, beri'ah,
yetsirah*, and *asiyyah*, usually abbreviated as *ABiYA*. (Isaac of Akko
is the first to use this abbreviation.) These four dimensions contain,
respectively, the ten sefirot, the divine throne and chariot, the an-
gels, and the terrestrial world. The sefirot are active in all four
worlds. Isaac sees the last of the sefirot directly above him and the
highest ones rising toward Ein Sof, the Infinite.

GATES OF HOLINESS

Hayyim Vital (sixteenth–seventeenth centuries), *Sha'arei Qe-
dushah*, Part 4, in *Ketavim Hadashim me-Rabbeinu Hayyim Vital*
(Jerusalem: Ahavat Shalom, 1988), 5, 10–11, 21–22.

aloneness Contemplative solitude and concentration.

timbrels, flutes, and other instruments See 1 Samuel 10:5, where
Samuel tells Saul: "As you enter the town, you will encounter a band
of prophets coming down from the shrine, preceded by lyres, tim-
brels, flutes, and harps, and they will be prophesying. The spirit of
YHVH will rush upon you, and you will prophesy along with them;
you will become another person."

"Enlighten my eyes . . . a steadfast spirit" Psalms 13:4; 51:12.

good deeds Hebrew, mitsvot, "commandments," the various com-
mandments of the Torah.

Shekhinah The divine presence.

WHAT ARE WE?

Abraham Isaac Kook (twentieth century), *Orot ha-Qodesh*, 3:270.

"What are we?" Exodus 16:7, spoken by Moses to the children of Is-
rael, referring to Aaron and himself. In Hasidism this verse serves as
a proof text for seeing through the illusion of the separateness of self.

THE VOICE OF GOD

Abraham Isaac Kook (twentieth century), *Orot ha-Qodesh*, 1:268.

Re'uyyot Yehezqel (fourth–fifth centuries), ed. Ithamar Gruenwald, in *Temirin* 1:111–14. See Gruenwald, *Apocalyptic and Merkavah Mysticism* (Leiden: E. J. Brill, 1980), 135–36; Cohen, *The Shi'ur Qomah: Liturgy and Theurgy in Pre-Kabbalistic Jewish Mysticism*, 2–3.

"As I was among the exiles on the River Kevar ... " Ezekiel 1:1. The prophet Ezekiel was apparently alone at the river, though at the time he was living in the community of Jews who had been exiled to Babylon by King Nebuchadnezzar II, who conquered Judea and destroyed Solomon's Temple in Jerusalem near the beginning of the sixth century B.C.E. The prophet Daniel also experienced several of his visions by the rivers of Babylon (Daniel 8:2; 10:4; 12:5). Ezekiel's river, Kevar, was apparently a stream near Nippur. In Hebrew, though, *kevar* means "already," and this meaning underlies the following parable.

Holiness Hebrew, *ha-qodesh*, the original form of what later became the common name for God in rabbinic literature: *ha-qadosh barukh hu*, the Holy One, blessed be he.

the Power Hebrew, *ha-gevurah*, a rabbinic name for God, expressing divine omnipotence. It often appears in the context of revelation.

the heavenly chariot The divine throne moving through heaven, described by Ezekiel in the first chapter of his book.

the River of Already Ezekiel sees divine visions reflected in the water. If he were told to look up to heaven and see God, he would respond, "I have seen him in the river already." Revelation is always already; it entails a sense of déjà vu. Discovering God is simultaneously new and ancient—an unexpected encounter and a primordial remembering. Reflected in the water is the highest, deepest dimension of self. Gazing at water developed into a kabbalistic technique of meditation; see "Ripples," p. 114.

GO TO YOUR SELF

The first comment on the verse from Genesis is from *Zohar* 1:78a (thirteenth century). The concluding passage is from Moses Zacuto (seventeenth century), printed in Shalom Buzaglo, *Miqdash Melekh* (Bnei Brak, Israel: Bet Ha-Sofer, 1974), 1:70b.

God said to Abram, "Go forth." Genesis 12:1.

"Go to your self" Hebrew, *lekh lekha*, usually translated "Get thee out," or "Go forth." The *Zohar* reads the words hyperliterally.

BEYOND CAPACITY

Abraham Isaac Kook (twentieth century), *Orot ha-Qodesh*, 2:527.

DANGERS OF CONTEMPLATION

THE ORIGIN OF THOUGHT

Azriel of Gerona (thirteenth century), *Perush ha-Aggadot*, 39–40 and variants; see Idel, *Kabbalah: New Perspectives*, 46–47; 293, n. 64.

her origin The second sefirah: Hokhmah, Wisdom.

can ascend no further Hokhmah is the limit of comprehension.

that to which thought cannot expand and ascend Keter, the highest sefirah, divine nothingness.

be severed From the body.

or else ... Ezra of Gerona, on whose commentary Azriel expands, expresses the alternatives somewhat differently (*Perush ha-Aggadot*, 39–40, variants): "Either you will confuse your mind and destroy your body or else, from forcing thought to grasp that which cannot be comprehended, your soul will ascend, be severed, and return to her root."

DROWNING

Isaac of Akko (thirteenth–fourteenth centuries), *Otsar Hayyim*, Moscow-Guenzburg manuscript 775, 161b; see Idel, *Kabbalah: New Perspectives*, 67; 306, n. 69.

"Show me your Presence" Exodus 33:18.

her palace Her body.

a vast ocean The ocean of the divine.

from conceiving Hebrew, *me-harher*, "conceiving, pondering," conceiving mental images. It is dangerous to become fixated on any particular image, even a sublime one; see "Mental Attachment," p. 115.

REVELATION AND TORAH

THE ESSENCE OF TORAH

Zohar 2:176a–b (thirteenth century); see Matt, *Zohar*, 38–39, 202–3.

Because of that view ... The man from the mountains claims to be a master of wheat, a master of Torah. In rabbinic literature (Babylonian Talmud, *Bava Batra* 145b) the phrase "master of wheat" means one who has mastered the oral traditions. Here in the *Zohar*, wheat and its products (kernels, bread, cake, and royal pastry) apparently symbolize the four levels of meaning in Torah (simple, midrashic, allegorical, and mystical). The mountain man's mastery is superficial. He knows only *peshat*, the plain sense, and when he learns that everything emerges from peshat, he concludes that he needs to know nothing more. After all, doesn't he have the essence? Usually in mysticism essence is the goal, but the *Zohar*'s parable indicates that essence is inadequate, unless it flowers into all that it can be. The master of wheat is wallowing in essence. Instead of venturing into the unknown, he reduces the unknown to the familiar. He misses the delights, reserved for those who savor the variety of flavors, the range of meanings.

An earlier, midrashic parable (*Seder Eliyahu Zuta*, 2) also compares Torah to wheat and insists on its creative transformation:

"There was a king who had two servants. He loved them with a complete love. He gave each of them a measure of wheat and a bundle of flax. The wise servant—what did he do? He took the flax and wove it into cloth. He took the wheat and made it into flour. He sifted it, ground it, kneaded it, and baked it. Then he arranged it on the table and spread the cloth over it. He left it until the king arrived. The foolish servant did nothing at all.

"After some time, the king came to his palace and said, 'My children, bring me what I gave to you.' One brought out the bread on the table covered with cloth. The other brought out the wheat in a box with the bundle of flax on top.

"When the Blessed Holy One gave the Torah to Israel, he gave it to them as wheat from which to produce bread, and as flax from which to produce cloth."

Zohar 3:152a (thirteenth century); see Matt, *Zohar*, 43–45, 204–207.

better than all of them Than all the stories of Torah, than all its ordinary words.

rulers of the world possess words more sublime Apparently referring to collections of moral fables and wisdom compiled for royal edification; see Matt, *Zohar*, 204.

all the words of Torah ... secrets A basic hermeneutical principle of the *Zohar*; cf. *Zohar* 2:55b: "There is no word in the Torah that does not contain many secrets, many reasons, many roots, many branches."

'He makes his angels spirits' Psalms 104:4, whose plain sense is "He makes winds his messengers." Rabbi Shim'on reads the verse hyperliterally to introduce his teaching.

they put on the garment of this world They appear as physical beings, for example, to Abraham; see Genesis 18:1–2.

Torah, who created them and all the worlds According to the Mishnah (*Avot* 3:14), Torah is the "precious instrument by which the world was created." See Harry A. Wolfson, *Philo*, 4th rev. ed. (Cambridge, MA: Harvard University Press, 1968), 1:243–45; and *Bereshit Rabbah* 1:1: "The Torah says, 'I was the instrument of the Blessed Holy One' ... The Blessed Holy One gazed into the Torah and created the world."

'Open my eyes ...' Psalms 119:18. According to tradition, the Psalms were composed by King David.

'the embodiment of Torah' Hebrew, *gufei torah*, "bodies of Torah." In rabbinic literature this term denotes the essential teachings of Torah; here the category is broadened to include all the commandments.

garments: the stories of this world Several of the Torah's commandments are clothed and conveyed in story; see Genesis 32:24–32; Numbers 9:6–14; 15:32–36; 27:1–11. Furthermore, biblical narrative often transmits moral teaching.

do not look at the garment, but rather at the body ... Such readers penetrate the narrative layer and concentrate on the commandments of Torah.

The wise ones Mystics, kabbalists.

those who stood at Mount Sinai According to the Midrash (*Shemot Rabbah* 28:4), the souls of all those not yet born were present at Sinai. Here the *Zohar* implies that only mystical souls were present. To be a mystic is to remember the primordial revelation.

look only at the soul, root of all, real Torah The mystics see through the outer, physical layers of Torah—both her garment of stories and her body of commandments—into her soul, real Torah. The nature of this soul soon becomes clear. The Jewish philosopher Philo, the Church father Origen, and the Sufi mystic Rumi convey similar ideas; see Matt, *Zohar*, 206.

the soul of the soul of Torah See below.

The Communion of Israel Hebrew, *keneset yisra'el*, "community of Israel." In rabbinic literature this phrase denotes the people of Israel, the Ecclesia of Israel. In the *Zohar*, keneset yisra'el refers to the sefirah of Shekhinah, the feminine divine presence, the divine counterpart of the people, that aspect of God most intimately connected with them, with whom they can commune. Here Shekhinah is described as the divine body clothed by the heavens who receives the soul, a higher sefirah.

the soul, Beauty of Israel The masculine aspect of God is the sefirah of Tif'eret Yisra'el, "the Beauty of Israel" (cf. Lamentations 2:1), the Holy One, blessed be he. Shekhinah receives him as the body receives the soul.

So she is the body of the soul This is not redundant. Rabbinic literature (Babylonian Talmud, *Yevamot* 62a) describes a cosmic body containing all souls. In Kabbalah this body is identified with Shekhinah. By receiving the soul of Tif'eret, she carries all human souls, which are engendered by the union of these two sefirot.

The soul we have mentioned . . . This refers not only to the immediately preceding lines but to the preceding paragraph: "The wise ones . . . look only at the soul." The mystics gaze into the soul of Torah, none other than the sefirah of Tif'eret, the Holy One, blessed be he. One of the names of this sefirah is the written Torah, while Shekhinah is the oral Torah. The hidden essence of Torah is God. The ultimate purpose of study is direct experience of the divine, who is real Torah; the search for meaning culminates in revelation.

The soul of the soul is the Holy Ancient One Aramaic, *attiqa qad-disha*. The Holy Ancient One is the primal manifestation of Ein Sof, the Infinite, through Keter, its Crown, the first sefirah—beyond both Shekhinah and Tif'eret.

As wine must sit in a jar . . . Cf. Mishnah, *Avot* 4:27: "Do not look at the jar, but rather at what is inside."

THE OLD MAN AND THE RAVISHING MAIDEN

Zohar 2:94b–95a, 99a–b, 105b, 114a (*Sava de-Mishpatim*) (thirteenth century); see Matt, *Zohar*, 121–26, 249–54.

the face of Shekhinah! Cf. Palestinian Talmud, *Eruvin* 5:1, 22b: "Whoever receives the face of his teacher [i.e., welcomes him], it is as if he receives the face of Shekhinah. . . . One who receives the face of his friend, it is as if he receives the face of Shekhinah." Cf. Genesis 33:10. The *Zohar* transforms the talmudic simile into a synonym for the *havrayya*, the mystical companions, who "are called the face of Shekhinah because Shekhinah is hidden within them. She is concealed and they are revealed" (*Zohar* 2:163b).

an old man, a donkey driver The rabbis of the *Zohar* often encounter donkey drivers and other colorful characters on the road who amaze them; see Matt, *Zohar*, 250. On the old man as archetype of wisdom, see Carl Jung, *The Archetypes and the Collective Unconscious, Collected Works* 9:1 (London: Routledge & Kegan Paul, 1959), 215–16.

'Who is a serpent . . .' These riddles confuse not only Rabbi Yose; the cryptic language is intended to mystify the reader as well. Much of the imagery in the first two riddles alludes to various stages in the process of *gilgul*, reincarnation, one of the most esoteric doctrines of the *Zohar*; see *Zohar* 2:99b–100a, 105b–106a; Scholem, *Kabbalah*, 344–50. The riddle of the ravishing maiden is expounded later in the passage.

Now two are three, and three are like one! The old man plus the two rabbis constitute a triad joined together. This represents one meaning of the old man's earlier cryptic reference to "one who is three," which, on another level, alludes to three parts of the soul; see Matt, *Zohar*, 251.

'YHVH is on my side . . .' Psalms 118:6–8. The old man, about to reveal secrets of Torah, begins by invoking divine protection and help.

In the presence of rabbis who have not proved themselves, he has misgivings about the venture. The quotation also reflects the hesitancy of the composer of the *Zohar*, Moses de León, to publish the secrets. For him, the human threat is posed by opponents of Kabbalah or by other kabbalists who might disapprove of his undertaking.

'Moses went inside the cloud . . .' Exodus 24:18.

'I have placed my bow in the cloud and it shall be a sign of the covenant between me and the earth' (Genesis 9:13). After the Flood, God displays a rainbow to Noah as a sign that he will never again inundate the world. Ezekiel (1:28) compares the divine presence to "the appearance of the rainbow in the clouds." In the *Zohar*, Rainbow is one of the many names of Shekhinah, the feminine divine presence who displays the colors of the sefirot. At Sinai she appeared wrapped in a cloud.

We have learned that the rainbow . . . Shekhinah, the rainbow, takes off her garment, the cloud, and gives it to Moses. Shielded by this cloud, he ascends the mountain and encounters the beyond.

in the all In the fullness of God.

The companions Rabbi Hiyya and Rabbi Yose.

A parable Based on the old man's riddle; see p. 138.

no one near him sees This appears to be the meaning of the phrase in the riddle: "a ravishing maiden without eyes"; that is, no eyes behold her.

derasha The "search" for meaning. Derasha (Hebrew, *derashah* or *midrash*) is the second level of meaning in Torah, after the literal sense. Through applying hermeneutical techniques and aided by imagination, the interpreter expands the meaning of the biblical text.

words riddled with allegory . . . *haggadah* The allegorical method of interpretation was prevalent among Jewish and Christian philosophers and is sometimes found in the *Zohar*; see Matt, *Zohar*, 252; Scholem, *On the Kabbalah and Its Symbolism*, 50–62. Here this method is called haggadah, "telling," expounding Torah allegorically.

all her hidden secrets The mystical dimension of Torah, the highest level and deepest layer of meaning.

primordial days According to rabbinic tradition, Torah existed before the creation of the world. "Primordial days" also alludes to the

six sefirot from Hesed to Yesod, who are called the six days of creation. They flow into Shekhinah, transmitting to her the emanation of "the hidden ways," the thirty-two wondrous paths of wisdom; see *Sefer Yetsirah* 1:1 ("The Ten *Sefirot*," p. 76); *Bahir*, Sec. 63.

husband of Torah, master of the house Having received her secrets, the lover of Torah becomes her husband. Elsewhere in the *Zohar* the phrase "master of the house" designates Moses, husband of Shekhinah; see Matt, *Zohar*, 105, 253. Here it is applied to any mystic who has mastered the secrets of Torah.

withholding nothing, concealing nothing This explains the cryptic phrase in the old man's riddle: "She adorns herself with adornments that are not." The initial encounter with Torah yields an apparent meaning that is only an adornment and a disguise. Seeing through this garment, the mystic discovers the naked reality of revelation; cf. "How to Look at Torah," pp. 135–37.

that word, that hint The word of Torah that first caught his attention.

Now the *peshat* of the verse, just like it is The root PSHT means "to strip, make plain, explain." The peshat is the plain meaning, sometimes contrasted with deeper layers of meaning. Here, instead of making contrasts, the old man points to the paradox of mystical study. The peshat is the starting point, the word on the page. As meaning unfolds, layer by layer, one encounters the face of Torah. This is revelation, enlightenment. But in Kabbalah, enlightenment leads back to the word; the peshat reappears as the upshot. One emerges from the mystical experience of Torah with a profound appreciation of her form. Cf. the Zen koan: "First there is a mountain; then there is no mountain; then there is."

Yeiva Sava Yeiva the Elder. The old man finally reveals his name.

'Set me as a seal ...' Song of Songs 8:6.

Rabbi Shim'on Their master, the hero of the *Zohar*.

his punishment For having insulted him.

these verses Proverbs 4:18, 12; Isaiah 60:21.

UNRIPE FRUIT OF WISDOM

Moses de León (thirteenth century), *Sefer ha-Rimmon* (*The Book of the Pomegranate*), ed. Elliot R. Wolfson (Atlanta: Scholars Press, 1988), 106–8, 326.

The written Torah and the oral Torah The Torah and its unfolding interpretations, symbolizing Tif'eret and Malkhut, the masculine and feminine aspects of God.

the sheer, inner voice Binah, the Divine Mother, the source of both Tif'eret and Malkhut.

Wisdom is the root . . . The sefirah of Hokhmah, Wisdom, is the primordial point from which Binah and the lower sefirot emerge.

"Torah is an unripe fruit of supernal wisdom." See *Bereshit Rabbah* 17:5: "Sleep is an unripe fruit of death. A dream is an unripe fruit of prophecy. The globe of the sun is an unripe fruit of the supernal light. *Shabbat* is an unripe fruit of the world-to-come. Torah is an unripe fruit of supernal wisdom."

its wondrous pathways See *Sefer Yetsirah* 1:1 ("The Ten *Sefirot*," p. 76): "thirty-two wondrous paths of wisdom."

"Open my eyes . . . " Psalm 119:18, traditionally ascribed to King David, the sweet singer of Israel; cf. "How to Look at Torah," p. 136. Through mystical understanding, one is able to discover the hidden wisdom of Torah and taste its ripeness.

WITHOUT VOWELS

Bahya ben Asher (thirteenth–fourteenth centuries), *Commentary on the Torah*, Numbers 11:15; see Idel, *Kabbalah: New Perspectives*, 213–14.

splinter into sparks The words sparkle with new and unforeseen meanings.

Without vowels . . . Cf. Jacob ben Sheshet, *Meshiv Devarim Nekhohim*, ed. Georges Vajda (Jerusalem: Israel National Academy of Sciences, 1968), 107: "The Torah scroll may not be vocalized—so that we can interpret every single word according to every possible reading." See Moshe Idel, "Infinities of Torah in Kabbalah," in Geoffrey H. Hartman and Sanford Budick, eds., *Midrash and Literature* (New Haven: Yale University Press, 1986), 141–57.

LIVING IN THE MATERIAL WORLD

THE JOURNEY OF THE SOUL

Moses de León (thirteenth century), *Sefer ha-Mishqal*, ed. Jochanan H. A. Wijnhoven (Ph.D. dissertation, Brandeis University, 1964), 46–47.

from the mystery of the highest level From the sefirah of Hokhmah, Wisdom.

By descending ... she is perfected Material existence is essential for the fulfillment of the soul. Cf. the less-holistic formulation of Plotinus, *Enneads* 4:8:5: "The soul, though it is divine and comes from above, enters the body and comes to this world by a spontaneous inclination, its own power and the setting in order of what comes after it being the cause of its descent. If it escapes quickly it takes no harm by acquiring a knowledge of evil, coming to know the nature of wickedness, and manifesting its powers, making apparent works and activities which if they had remained quiescent in the spiritual world would have been of no use because they would never have come into actuality; and the soul itself would not have known the powers it had if they had not come out and been revealed."

BRINGING FORTH SPARKS

Isaac Luria (sixteenth century), a kavvanah (spiritual "intention") recorded by Joseph Don Don, ca. 1570; see Ronit Meroz, "Luria's Sermon in Jerusalem and the *Kavvanah* on Eating," in Rachel Elior and Yehuda Liebes, eds., *Proceedings of the Fourth International Conference on the History of Jewish Mysticism: Lurianic Kabbalah* (Jerusalem: Hebrew University, 1992), 247.

Sparks of holiness ... According to Isaac Luria, sparks of divinity are scattered throughout the cosmos, as a result of the primordial catastrophe of "the breaking of the vessels." See the introduction, p. 15.

"One does not live on bread alone ... " Deuteronomy 8:3.

breathed into us by God See Genesis 2:7, the account of the creation of Adam: God "blew into his nostrils the breath of life."

motsi ... "bringing forth." The motsi is the traditional blessing over bread recited at the beginning of a meal.

TASTING THE SPARKS

Alexander Susskind (eighteenth century), *Yesod ve-Shoresh ha-Avodah* (Israel: 1968), 7:2, 60a.

Levi Yitshaq of Berditchev (eighteenth century), *Qedushat Levi*
(Jerusalem: Pe'er, 1972), *Va-Yeshev*, 26a–b.

RAISING THE SPARKS

Abraham Isaac Kook (twentieth century), *Orot ha-Qodesh*, 3:184.

EVERYTHING ASPIRES

Abraham Isaac Kook (twentieth century), *Orot ha-Qodesh*, 2:374.

SECULAR AND HOLY

Abraham Isaac Kook (twentieth century), *Orot ha-Qodesh*, 2:311.

THE SONG OF SONGS

Abraham Isaac Kook (twentieth century), *Orot ha-Qodesh*,
2:444–45.

SEXUAL HOLINESS

Iggeret ha-Qodesh, anonymous (thirteenth century), chapters 2, 5, 6;
see Seymour J. Cohen, tr., *The Holy Letter: A Study in Medieval
Jewish Sexual Morality* (New York: Ktav, 1976), 41–45, 57, 61,
123–25, 141.

union is called *knowing* As in "Adam knew Eve, his wife" (Genesis
4:1).

the sense of touch is shameful See Aristotle, *Nicomachean Ethics*
3:10; Maimonides, *Guide of the Perplexed* 2:36. Aristotle condemns
not the sense of touch *per se* but rather self-indulgence: "The sense
[of touch] with which self-indulgence is connected is the most widely
shared of the senses; and self-indulgence would seem to be justly a
matter of reproach, because it attaches to us not as men but as ani-
mals. To delight in such things, then, and to love them above all oth-
ers, is brutish." Maimonides puts words into his Greek mentor's
mouth, claiming in the *Guide* that according to Aristotle, the sense of
touch "is a disgrace to us." Maimonides approves wholeheartedly:

"How fine is what he [Aristotle] said, and how true it is that it is a disgrace! For we have it in so far as we are animals like the other beasts, and nothing that belongs to the notion of humanity pertains to it."

"God saw everything . . . " Genesis 1:31.

"The two of them were naked . . . " Genesis 2:25.

contemplating the pure forms Hebrew, *asuqin ba-muskalot*, "engaged in the intelligibles," that is, contemplating the ideal forms of reality.

"When a man unites with his wife . . . " Cf. Babylonian Talmud, *Sotah* 17a.

She and he Thought and her source.

the meditator Hebrew, *ba'al ha-mahashavah*, "the master of thought."

HOLY PLEASURE

Barukh ben Abraham of Kosov (eighteenth century), *Ammud ha-Avodah* (Czernowitz, 1863), 33b; see Tishby, in *Zion* 32 (1967): 27–29, n. 122; David Biale, *Eros and the Jews: From Biblical Israel to Contemporary America* (New York: Basic Books, 1992), 124–25.

"Be fruitful and multiply" God's first words to the first human couple, according to Genesis 1:28.

"One should hallow oneself during sexual union" See Babylonian Talmud, *Shevu'ot* 18b; *Niddah* 70b–71a; *Zohar* 1:112a (*Midrash ha-Ne'elam*); *Iggeret ha-Qodesh*, end of chapter 1.

THE GIFT OF HOLINESS

Moses Hayyim Luzzatto (eighteenth century), *Mesillat Yesharim: The Path of the Upright*, ed. and tr. Mordechai M. Kaplan (Philadelphia: Jewish Publication Society, 1936), chapter 26, 221–24.

THE WISDOM OF KABBALAH

HOW TO APPROACH KABBALAH

Moses Cordovero (sixteenth century), *Or Ne'erav*, ed. Yehuda Z. Brandwein, 1:6 (15a, 16b); 3:3 (24a–25a); see Robinson, *Moses Cordovero's Introduction to Kabbalah*, 39, 42–43, 65–68.

dividing your time ... In rabbinic literature (Babylonian Talmud, *Qiddushin* 30a), the ideal study schedule is given: Divide your time between Bible, Mishnah, and Talmud. Maimonides (*Mishneh Torah*, "The Study of Torah," 1:11–12) alters the list: written Torah, oral Torah, and extended periods of reasoning, reflection, and contemplation.

to pray ... Shekhinah The study of Kabbalah includes directions on how to focus the words of prayer on particular sefirot, in order to unite these various aspects of God. The union of Tif'eret and Shekhinah, the masculine and feminine halves of divinity, represents the goal of prayer and mitsvot.

Rabbi Shim'on bar Yohai ... *Zohar* The *Zohar* is traditionally attributed to the second-century sage Rabbi Shim'on; see the introduction.

Sefer Yetsirah* and *Sefer ha-Bahir *Sefer Yetsirah* (*The Book of Creation*) is a work of cosmology and letter and number mysticism, composed between the third and sixth centuries. *Sefer ha-Bahir* (*The Book of Brightness*) was edited in Provence toward the end of the twelfth century; see the introduction.

The Fountain of Wisdom Hebrew, *Ma'ayan ha-Hokhmah*. For a translation, see Verman, *The Books of Contemplation*, 49–64. *Chapters of the Chariot* and *Chapters of Creation* are texts of early rabbinic mysticism.

"I have been pursuing this word ..." See *Zohar* 3:168a: "Rabbi Shim'on bent down and kissed the dust. He said, 'Word, word! I have been pursuing you since the day I came to be! Now the word has been revealed to me from the root of all.'"

HIDDEN WISDOM

Menahem Mendel of Peremishlany (eighteenth century), quoted by his disciple, Meshullam Phoebus of Zbaraz, *Yosher Diverei Emet* (Munkacs, Hungary: Kahan & Fried, 1905), 18c–d; see Idel, *Kabbalah: New Perspectives*, 58; 300, n. 160. Cf. the statement of Menahem of Lonzano, cited by Idel, *Kabbalah: New Perspectives*, 301, n. 163: "Unless you are stripped of your physical nature, you cannot understand even one dot of the holy *Zohar*, even though you think you know."

the *Ari* "The Lion," Isaac Luria, the famous sixteenth-century kabbalist of Safed; see the introduction. *Ha-Ari* is an acronym for *Ha-Elohi Rabbi Yitshaq*, "the divine Rabbi Isaac."

Sefer ha-Bahir, Sec. 150, 65 (twelfth century).

mysticism Hebrew, *ma'aseh vere'shit u-ma'aseh merkavah*, "the workings of creation and the workings of the chariot," the secrets of cosmology (based on Genesis 1) and the secrets of the divine realm (based on Ezekiel 1). These constitute the two branches of early Jewish mysticism; see the introduction.

"This stumbling block is in your hand" Isaiah 3:6.

unless you stumble over them Cf. Babylonian Talmud, *Gittin* 43a: "'This stumbling block is in your hand.' One does not understand words of Torah unless one has stumbled over them."

Suggested Reading

Ariel, David. *The Mystic Quest: An Introduction to Jewish Mysticism.* New York: Schocken Books, 1992. A readable, comprehensive guide.

Bokser, Ben Zion, ed. *The Jewish Mystical Tradition.* Northvale, NJ: Jason Aronson, 1993. An anthology of texts from biblical origins to the twentieth century.

Dan, Joseph, ed., and Ronald C. Kiener, tr. *The Early Kabbalah.* The Classics of Western Spirituality. Mahwah, NJ: Paulist Press, 1986. Selections from the formative period of Kabbalah: twelfth- and thirteenth-century Provence and Spain.

Fine, Lawrence, ed. *Essential Papers on Kabbalah.* New York: New York University Press, 1995. A stimulating collection of studies by leading scholars in the field.

——. "Kabbalistic Texts." In *Back to the Sources: Reading the Classic Jewish Texts,* edited by Barry W. Holtz, 304–59. New York: Summit Books, 1984. A clear, concise presentation of the development of Kabbalah and its symbolism.

——, ed. and tr. *Safed Spirituality: Rules of Mystical Piety, The Beginning of Wisdom.* The Classics of Western Spirituality. Mahwah, NJ: Paulist Press, 1985. A fascinating depiction of the mystical community of Safed and some of its leading personalities, along with a text of mystical ethics.

Green, Arthur, ed. *Jewish Spirituality.* Volume 1: *From the Bible through the Middle Ages.* Volume 2: *From the Sixteenth-Century Revival to the Present.* New York: Crossroad, 1986, 1988. A stimulating collection of studies by prominent scholars.

Idel, Moshe. *Kabbalah: New Perspectives.* New Haven: Yale University Press, 1988. A groundbreaking, challenging work by a leading authority in the field.

——. *The Mystical Experience in Abraham Abulafia.* Albany: State University of New York Press, 1988. A penetrating study of the prime representative of ecstatic Kabbalah.

Jacobs, Louis. *Jewish Mystical Testimonies.* New York: Schocken, 1977. A collection of first-person accounts of mystical experience.

Kaplan, Aryeh. *Meditation and Kabbalah.* York Beach, ME: Samuel Weiser, 1982. A rich collection of texts presented by a practicing kabbalist.

Liebes, Yehuda. *Studies in the Zohar.* Albany: State University of New York Press, 1993. Stimulating studies of the major work of Kabbalah by a leading authority in the field.

Matt, Daniel C. "*Ayin:* The Concept of Nothingness in Jewish Mysticism." In Fine, *Essential Papers on Kabbalah,* 67–108.

——. "The Mystic and the *Mitsvot.*" In Green, *Jewish Spirituality: From the Bible through the Middle Ages,* 367–404. A study of the spiritual significance of religious action in Kabbalah.

——, ed. and tr. *Zohar: The Book of Enlightenment.* The Classics of Western Spirituality. Mahwah, NJ: Paulist Press, 1983. Annotated, poetic translations of selections from the major work of Kabbalah.

Patai, Raphael. *The Hebrew Goddess,* 3d rev. ed. Detroit: Wayne State University Press, 1990. A biography of the feminine divinity, from her roots in the ancient Near East through the Kabbalah.

Scholem, Gershom. *Kabbalah.* Jerusalem: Keter, 1974. A collection of Scholem's articles from the *Encyclopaedia Judaica.* The most comprehensive single volume on the Kabbalah, covering its historical development and major concepts and personalities.

——. *Major Trends in Jewish Mysticism,* 3d rev. ed. New York: Schocken, 1961. The classic work by the scholar who made Kabbalah accessible to the modern world.

——. *On the Kabbalah and Its Symbolism.* New York: Schocken, 1965. Fascinating essays on Torah, myth, ritual, and other topics.

——. *On the Mystical Shape of the Godhead.* New York: Schocken, 1991. Superb essays on Shekhinah (the feminine aspect of God), good and evil, transmigration, and other topics.

——. *Origins of the Kabbalah*. Philadelphia: Jewish Publication Society, 1987. Tracing the growth of Kabbalah from its beginnings through the middle of the thirteenth century.

Tishby, Isaiah and Fischel Lachower. *The Wisdom of the Zohar: An Anthology of Texts.* Three volumes. Oxford: Oxford University Press, 1989. Annotated translations arranged thematically, with masterful, extensive introductions.

Wolfson, Elliot R. *Along the Path: Studies in Kabbalistic Myth, Symbolism, and Hermeneutics.* Albany: State University of New York Press, 1995.

——. *Circle in the Square: Studies in the Use of Gender in Kabbalistic Symbolism*. Albany: State University of New York Press, 1995. Two vibrant collections by an expert in the field.

——. *Through a Speculum That Shines: Vision and Imagination in Medieval Jewish Mysticism*. Princeton, NJ: Princeton University Press, 1994. An enlightening treatment of visionary experience in a wide range of Jewish mystical texts.